Face Value: American Portraits

FACE VALUE:
AMERICAN PORTRAITS

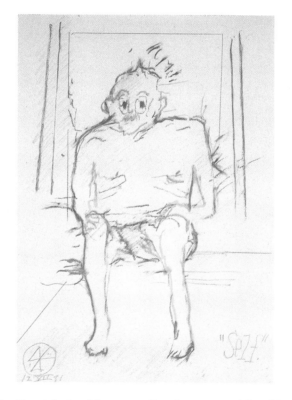

Donna De Salvo

with contributions by

Maurice Berger

Max Kozloff

Kenneth E. Silver

Michele Wallace

The Parrish Art Museum, Southampton, New York
Flammarion
Paris–New York
1995

This catalogue accompanies the exhibition *Face Value: American Portraits*, organized by The Parrish Art Museum, Southampton, New York

EXHIBITION ITINERARY

The Parrish Art Museum, Southampton, New York
July 16–September 3, 1995

Wexner Center for the Arts, Columbus, Ohio
February 3–April 21, 1996

Tampa Museum of Art, Tampa, Florida
July 14–September 8, 1996

Edited by Sheila Schwartz
Designed by ReVerb / Los Angeles
Photo engraving by Pollina SA, Luçon / France
Printed and bound by Pollina SA, Luçon / France
Published by The Parrish Art Museum, Southampton, New York and Flammarion, Paris–New York

© 1995 The Parrish Art Museum

Flammarion, 26, rue Racine, 75006 Paris

ISBN: 2-08013-597-X
NUMÉRO D'ÉDITION: 0993
DÉPÔT LÉGAL: September 1995
Printed and bound in France

1. FRONTISPIECE WILLIAM KING SELF 1981

The planning phase of Face Value: American Portraits *was made possible with generous support from The Andy Warhol Foundation for the Visual Arts and with public funds from the New York State Council on the Arts.*

The exhibition and catalogue are made possible with generous support from the Lannan Foundation, the Herman Goldman Foundation, an anonymous donor, the Fanwood Foundation and with public funds from the New York Council for the Humanities, a state program of the National Endowment for the Humanities.

LENDERS TO THE EXHIBITION

Mr. and Mrs. Michael Arlen

The Eli Broad Family Foundation, Santa Monica

Leo Castelli

Christo and Jeanne-Claude

Mrs. Werner Dannheisser

James Danziger Gallery, New York

Ronald Feldman Fine Arts, New York

Fischbach Gallery, New York

Howard Greenberg Gallery, New York

Lyle Ashton Harris

Ellen Kern

Sarah-Ann and Werner H. Kramarsky

Barbara and Richard S. Lane

Rudean Leinaeng

Metro Pictures, New York

Robert Miller Gallery, New York

Hartley and Richard Neel

P.P.O.W., New York

Max Protetch Gallery, New York

Gallery Schlesinger, New York

Toby R. Spiselman

Billy Sullivan

Jack Tilton Gallery, New York

The Andy Warhol Foundation for the Visual Arts, Inc.

Whitney Museum of American Art

Estate of Hannah Wilke

one anonymous lender

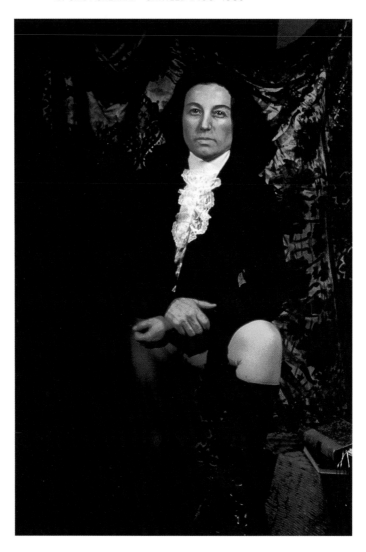

TABLE OF CONTENTS

In eighteenth-century America, portraiture was the major pictorial art of the colonies. For a fee, itinerant tradesmen, called limners, would paint faces on canvas or wood, or create miniatures. As the colonies grew and prospered, portraiture style expanded from the somber and stately to include playful poses with decorative elements. Nevertheless, most patrons continued to value exactitude rather than artistic judgment or inspiration.

In the early nineteenth century, when art as a profession first took hold in America, artists began to detest their service to portraiture and to the capriciousness of their clients and sitters. As the century advanced, different kinds of pictures flourished; new frontiers were explored and extraordinary landscapes were depicted. Large-scale paintings and panoramas toured the country and illustrated books and magazines, prints, engravings, and then photographs proliferated.

Twentieth-century American artists have renewed interest in portraiture, in part through the inventions of modernism, the creative use of photography and employing new forms of expression. The essays in this catalogue and the selected materials and works of art in the exhibition *Face Value: American Portraits*, trace these shifts as they have come about since the late nineteenth century. The portraits tell us a great deal about our cultural and social interests, about our patronage and politics, about our art and morals, and about our propaganda and commerce. Above all, they provide us with a view of our common humanity.

I am especially appreciative of Donna De Salvo, Robert Lehman Curator, for her continued interest in discovering ways to interpret our collection in the context of contemporary ideas. Her sense of the timely and innovative within the artistic community, and its associations with the past is a special gift, one which has attracted a lively and thoughtful team of scholars and critics: Maurice Berger, Stuart Ewen, Kenneth Silver, Linda Norden, Max Kozloff, and Michele Wallace. I thank them all for sharing their sentiments and thinking about the subject of portraiture.

Of equal importance has been the extraordinary skill and intelligence which the Parrish's very dedicated staff brings to this effort. Our deputy director, Anke Jackson, orchestrates with grace and patience all the parts, keeping us aware of the whole of its meaning; our registrar, Alicia Longwell, goes well beyond the details of loan arrangements and assembling this catalogue; and our education staff, curator Martha Stotzky, program assistants Alexandra Cromwell and Cara Conklin, have provided rich programming for this exhibition. For their

respective parts in the formidable tasks of research, typing manuscripts, designing the catalogue, and installing the exhibition, we are very grateful to Lorraine Wild, Whitney Lowe, Sheila Schwartz, Sara Blackburn, Joan Burgess, Justin Topping, Pat Pickett, Pete Pantaleo, Robin Box-Klopfer, Rob Schumann, Andrea Gurvitz and Diana Barnes.

I would especially like to thank individuals who have given financial support over the years to our exhibition program and to this particular project. As a group they are of exceptional character, curious, attentive and enthusiastic about curatorial interests. I wish to convey my sincere appreciation to Mildred C. Brinn, Werner Kramarsky, William P. Rayner, Christopher Schwabacher, Helene B. Stevens and Paul F. Walter. In addition we have received generous support from the New York State Council on the Arts, the Andy Warhol Foundation for the Visual Arts, the Lannan Foundation, the Herman Goldman Foundation, and New York Council for the Humanities for which I am very appreciative.

I am grateful to the lenders of works of art—artists, dealers, collectors—all who would share their pleasures with us; and, to those who over the years, have made significant gifts to our holdings which comprise a large part of this exhibition.

And lastly, I am blessed with a board of trustees who under the leadership of Mildred C. Brinn, chairman, and Wilbur Ross, Jr., president, give us support and encouragement to venture far and wide with our ideas.

Trudy C. Kramer DIRECTOR

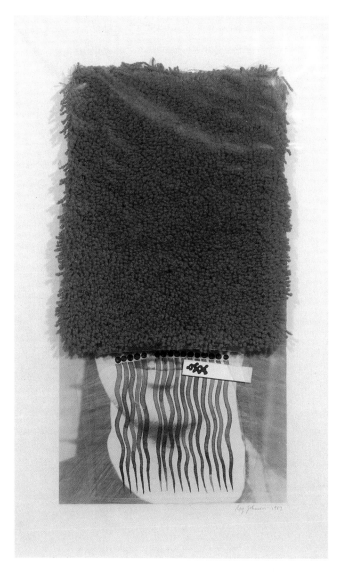

3. Ray Johnson Green 1989

Acknowledgments

Face Value: American Portraits was conceptualized as a dialogue between contemporary developments in portraiture and portraits in the permanent collection of The Parrish Art Museum. Its realization and the accompanying catalogue were made possible through the generosity of many people. I was fortunate to have the advice of five individuals who served as consultants to this project, each of whom has contributed a voice and vision to shaping the exhibition and catalogue: Maurice Berger, senior fellow, The Vera List Center for Art and Politics; Stuart Ewen, professor of communications, Hunter College; Max Kozloff, critic; Linda Norden, assistant professor of Art, Bard Center for Curatorial Studies; and Michele Wallace, associate professor of literature and women's studies, City College of New York. Maurice Berger, Max Kozloff, and Michele Wallace also contributed catalogue essays to bring fresh perspectives to the topic of portraiture. In addition to authoring an essay, Kenneth E. Silver generously provided critical insights into the exhibition's organization and installation.

Following its showing at The Parrish Art Museum, *Face Value: American Portraits* will travel to two other venues. I would like to thank my colleagues at those institutions for their willingness to host the exhibition: R. Andrew Maass and Douglas Dreishpoon, The Tampa Museum of Art; and Sherri Geldin and Sarah J. Rogers, The Wexner Center for the Arts, University of Ohio, Columbus.

The participation of our co-publisher, Flammarion, has enabled us to produce a substantial publication, and I owe special thanks to Suzanne Tise, director of English-language publications, for her willingness to support this undertaking. Lorraine Wild and Whitney Lowe of ReVerb Studios employed their innovative approach to image and text in designing an extraordinary publication, and Sheila Schwartz's excellent editorial skills helped shape the essays and catalogue. I also wish to thank several individuals who helped arrange for some of the catalogue reproductions: David Hidalgo, M.D., chief of plastic and reconstructive surgery, Memorial Sloan-Kettering Cancer Center; Amy Schwartz, Denise Degliantoni, and Kelly Corroon, The Gap; Patricia S. Mercadante, Schieffelin and Somerset Company; Julie Gordon, Leo Burnett, U.S.A.; Sylvia Woolf Gallop, Binny & Smith, Inc.; and Sandy Jones, Ogilvy and Mather.

I would like to express my gratitude to the private individuals, galleries, artists and museums whose continued willingness to lend works of art makes possible projects such as these: John Cheim, Robert Miller Gallery; David Maupin and Jennifer Ho, Metro Pictures; Wendy Olsoff and Penny Pilkington, P.P.O.W. Gallery; Suzanne Dunne and Douglas Baxter,

PaceWildenstein Gallery; Ronald Feldman and Mark Nochella, Ronald Feldman Fine Arts; Michele De Angelus, The Eli Broad Family Foundation; Jack Tilton, Jack Tilton Gallery; Andrea Rosen and Michelle Reyes, Andrea Rosen Gallery; Marianne Courville and Blair Rainey, James Danziger Gallery; Xavier LaBoulbenne, Max Protetch Gallery; Vincent Fremont, Tim Hunt, Heloise Goodman, and Jane Rubin, The Andy Warhol Foundation for the Visual Arts, Inc.; Howard Greenberg, Howard Greenberg Gallery; David A. Ross, Adam D. Weinberg and Nancy McGary, Whitney Museum of American Art.

When the call for portraits became public, numerous artists sent slides and told me about their work. Although it would be impossible for any exhibition to contain all these submissions, it was an enlightening experience to observe the numerous variations on the theme of portraiture, being produced today. Other individuals have generously offered advice and helped locate works; for these efforts, I am deeply grateful to Joan Washburn, Jerry Salz, Mason Klein, Craig Cornelius, Lauren Sedofsky, Phyllis Stigliano, William Stover, and Frances Beatty.

At The Parrish Art Museum, this project has had the enthusiastic cooperation of many people. I would like to thank Mildred C. Brinn, chairman, and the entire Board of Trustees for their support of innovative thinking. A special thanks is due to Trudy C. Kramer, director, who encouraged this project from its inception. Anke Jackson, deputy director, shepherded the project through sometimes difficult seas, always ensuring its safe voyage. My colleagues in the Museum's Education Department, Martha Stotzky, curator, and Alexandra Cromwell, coordinator of adult programs, have organized a splendid array of programs. My assistant, Joan Burgess, cheerfully prepared numerous materials required for this project, as did my former assistant, Diana Barnes, during the project's early stages. Many other staff members contributed in various ways: Justin Topping, Pat Pickett, Pete Pantaleo, Robin Box-Klopfer, Nina Madison, Rob Schumann, Andrea Gurvitz, and Cara Conklin. A special thanks is due Alicia Longwell, the Museum's registrar, whose contribution far exceeded the requirements of her position. Beyond ensuring the safe handling of the works of art, she has been a trusted adviser and friend whose wit and wisdom kept me going throughout the organization of this project.

I would like to reserve my final thanks for the artists represented in this exhibition for their willingness to dwell in that uncertain space somewhere between convention and the unknown and for sending back snapshots of what it looks like.

D.D.S.

4. Judith Joy Ross Untitled, from Portraits at the Vietnam Veterans Memorial,
Washington, D.C. 1983–84

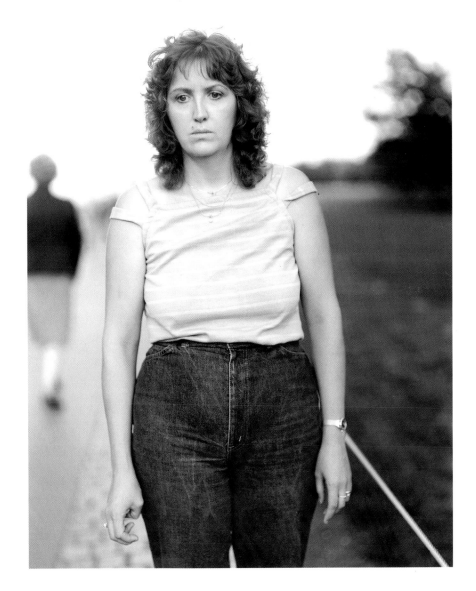

5,6. JUDITH JOY ROSS UNTITLED, FROM PORTRAITS AT THE VIETNAM VETERANS MEMORIAL,
WASHINGTON, D.C. 1983-84

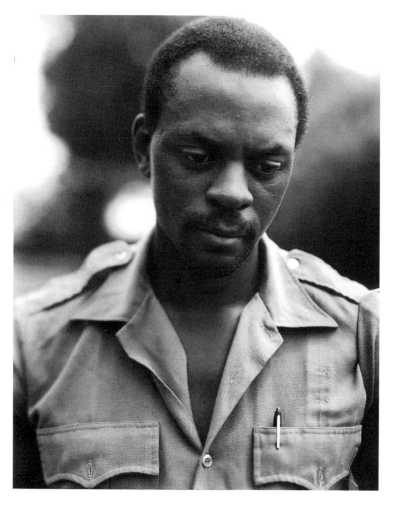

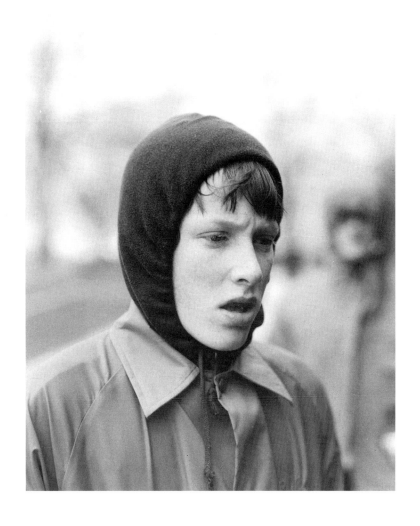

FACING BOTH WAYS: SOME THOUGHTS ON PORTRAITURE TODAY

Donna De Salvo

A series of anonymous faces, each a different, unnamed person, have a common denominator. Each was photographed by Judith Joy Ross at Washington's Vietnam Veterans Memorial be-
PLATES 4–6
tween 1983 and 1984. Ross' faces sometimes express anguish, sometimes anger, but more often than not a subtle, curious sadness seems to prevail. For some, it may be a personal connection to the memorial, perhaps a memory of one lost in the war, for others, the kind of participation in collective national grief that such monuments evoke. Ross photographed quickly, using a large-format camera equipped with a lens that produced a soft image. "The world isn't as sharp as they make lenses," she once remarked.[1] The prints themselves are made with a nineteenth-century technique in which negative and paper are exposed to sunlight, for as little as ten minutes or as long as several hours. In the series, as in her other work, Ross shows us what only a face can show.

Like the Vietnam Memorial itself, Felix Gonzalez-Torres' word-portraits consist only of
PLATE 7
words. Torres, who was born in Cuba and moved to New York in 1979, began his word-portraits in 1986. Commemorating individuals, institutions or historical events, they are distinct for their absence of faces. According to the artist, "When you look at a photograph of someone you don't know, you bring your own connotations to a denoted set of characteristics. In other words, from an image you switch to language, which is the only way we humans can 'read' an image. In these portrait-pieces, I try to reverse the process. I start with language and then ask the viewer to provide an image."[2] Torres creates a sort of non-chronological timeline, in which a portrait evolves from the significant dates and events provided by the subjects themselves. They read like a résumé, a kind of Dewar's ad of moments and achievements.

FIG. 8

At first glance, it appears that Torres has provided us with far more specific information about an individual than we could ever glean from Ross' photographs. And yet these two approaches to portraiture have a great deal in common. Each is filled with gaps, with blank spaces; neither results in any revelatory single "truth." Together, however, they are reminders that we are not the sum of our facial expressions, nor are we a catalogue of events. Human identity is far more shifting and impermanent.

The position of portraiture today is not easy to assess. In fact, it is a rather messy enterprise. And it is complicated by the use of the term "portrait" to encompass a wide range of visual activity, from official commissioned portraits, to family photographs and advertising images, to the work of artists who see portraiture as a revealer of "essence and truth"—and to those who challenge this assumption. Despite this slippery nature, or perhaps because of it, portraiture today has a high profile.

One indication of its hold on our current visual preoccupations is the renewed attention

[1] Quoted in Vicki Goldberg, *Judith Joy Ross*, exh. brochure (New York: James Danziger Gallery, 1991), p. 6.

[2] Quoted in *Felix Gonzalez-Torres*, exh. brochure (Washington, D.C.: Hirshhorn Museum and Sculpture Garden, Smithsonian Institution, 1992), n.p.

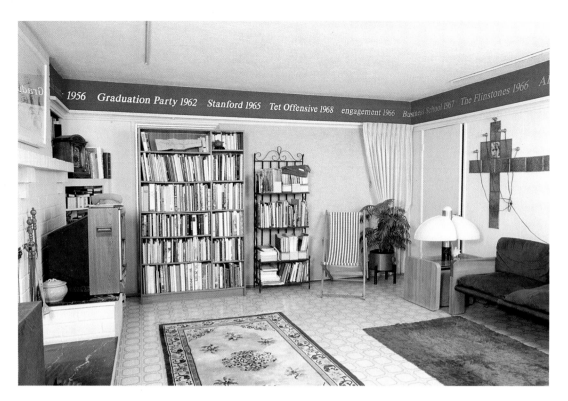

7. FELIX GONZALEZ-TORRES UNTITLED (PORTRAIT OF THE WONGS) 1991
PAINTED WALL, DIMENSIONS VARIABLE. COLLECTION OF LORRIN AND DEANE WONG;
COURTESY ANDREA ROSEN GALLERY, NEW YORK.

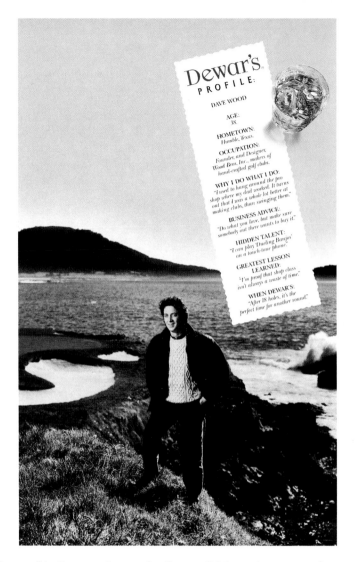

8. Dewar's "Profiles" Ad Campaign. Courtesy Leo Burnett, U.S.A., and Schieffelin & Somerset, New York.

9. American Express Card. Courtesy American Express.

being given to artists identified with the genre, artists such as Chuck Close and Richard Avedon. Another is the number of exhibitions that have taken place, or are in the planning stages, which take contemporary portraiture as their theme. *Face Value: American Portraits*, is one attempt to open up a discussion of portraiture by exploring a range of work by contemporary artists whose primary language has been portraiture, or forms related to it, within the context of a museum collection. A consideration of the topic only within an art context, however, would omit the impact of "face value" in advertising and other forms of mass culture, all of which contribute to the formation of image and identity in everyday life, as Michele Wallace discusses in her essay in this catalogue.

FIGS. 9, 10

Like many museums, The Parrish Art Museum has made portraiture a major theme in its collection, which reflects the importance of the tradition in nineteenth-century America. *Face Value*, however, is not a historical survey of portraiture. Rather, the unique resources of The Parrish Art Museum—significant holdings by two of America's foremost portrait painters, William Merritt Chase and Fairfield Porter, as well as works by artists such as Robert Henri, Peggy Bacon, Moses Soyer, Larry Rivers, and Chuck Close—make it possible to present selected dialogues between artists of the past and their modern-day counterparts. "Selected" is a key word, because no single undertaking could possibly cover the breadth of work and approaches being practiced today; nor can the various categories of interpretation be fixed. Nevertheless, the very diversity of the portraits in this exhibition and catalogue testifies to the almost unlimited range of interpretations conceived by the artistic imagination.

From William Merritt Chase and Robert Henri to Alice Neel and Moses Soyer, American portraits, whatever their aesthetic style, were instantly definable as traditional portraits. During the 1950s heyday of Abstract Expressionism, Fairfield Porter, Alex Katz, Elaine de Kooning, and Larry Rivers dramatically expanded the language of portraiture, making portraits that were also modernist paintings.[3] During the past thirty years, a number of expressive forms have emerged that have been recognized as portraiture, along with others that have impacted on it. During the 1960s,

PLATE 11

[3] For a superb discussion of this topic, see Paul Schimmel and Judith E. Stein, *The Figurative Fifties: New York Figurative Expressionism*, exh. cat. (Newport Beach, California: Newport Harbor Art Museum, 1988).

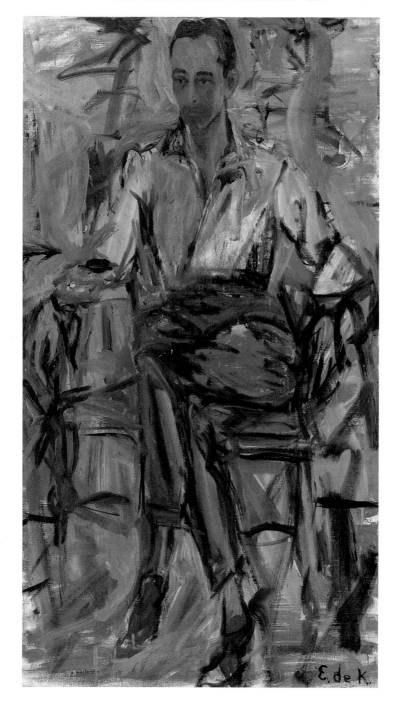

1911 . Elaine de Kooning Leo Castelli 1954

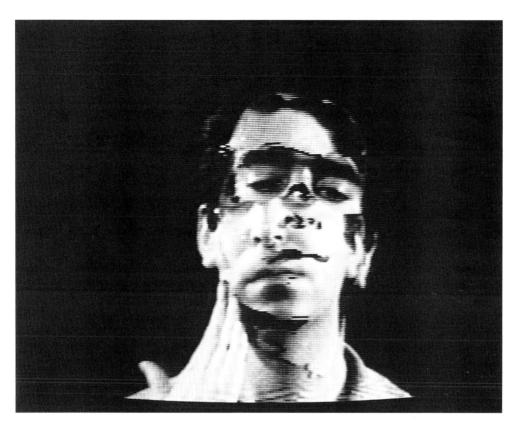

12. PETER CAMPUS FILM STILL FROM THREE TRANSITIONS 1973

Andy Warhol and Chuck Close brought the concerns of Pop art and Minimalism to their investigations. Hannah Wilke used performance to explore the relationship between self and audience. More recently, the portrait form has been employed by artists such as Cindy Sherman and Peter Campus to challenge basic assumptions of authenticity, truth, and authorship. Or, as in the case of Lyle Ashton Harris and Carrie Mae Weems, the portrait has become a form against which issues of identity, especially as they relate to race and sexuality, are being defined. Still other artists, such as Felix Gonzalez-Torres, have used the format of the commissioned portrait to expose the boundaries between private self and public life.

"What is a portrait?" is the question this exhibition poses for each viewer. What do we look for? And what do we see? What all portraits have in common is that they take people as their subjects. Looking at a portrait, we are allowed to get as close as possible and stare as long as we like—an opportunity rarely accorded in everyday public life, where we abruptly look away once our gaze has been returned. In the work of art, it is with the return gaze that we begin.

Much of the theoretical work of the 1970s questioned notions of originality and authorship that had been central to the Western belief in individuality and selfhood. The intense examination of image-making that preoccupied many artists during the 1980s focused on strategies of representation culled from media and advertising. Thus, it comes as no surprise that portraiture, which is so directly related to how we see ourselves, should reemerge as a subject of aesthetic inquiry. Several artists, such as Bruce Nauman, Peter Campus, Cindy Sherman, Eleanor Antin, and Hannah Wilke, have used the strategies of performance to problematize the notion of the portrait by casting it as a shifting set of performative acts, a concept examined by Max Kozloff in his essay for this catalogue.

From 1971 to 1978, Peter Campus produced a number of videos in which he explored how the self is created through the transformative powers of the video medium. In his 1973 video, *Three Transitions*, Campus performed three specific video illusions with the technique of chroma-keying. In one "transition," he rubs his hands over his face as if putting on makeup; but instead of adding to the surface of his face, his skin dissolves away and reveals beneath it yet another image of the artist. In another segment, Campus is pictured burning a sheet of paper on which his own face seems to appear. The paper is then replaced with a live image of the artist, and we see him watching the image of his own face burn away. Each of these illusions leaves us wanting, wondering what it is we are actually seeing.

To some people, Cindy Sherman's series of glossy black-and-white photographs, in which she assumed filmic personas, frequently masked in stylized garb or fake body parts, represent a form of anti-portrait. Although her work at first seems to have little to do with the genre of portraiture, Sherman in fact exposes the problems inherent in a fixed definition of identity. Rather than reveal something specific to us about an individual, she casts herself in a range of roles, frequently scripted by others. In later images, Sherman switched to large-format color photographs, their size more equal to that of paintings. In a series of "history portraits," begun in 1989, she takes on the genre of

PLATE 12

PLATE 13

13. Cindy Sherman Untitled Film Still, #48 1979

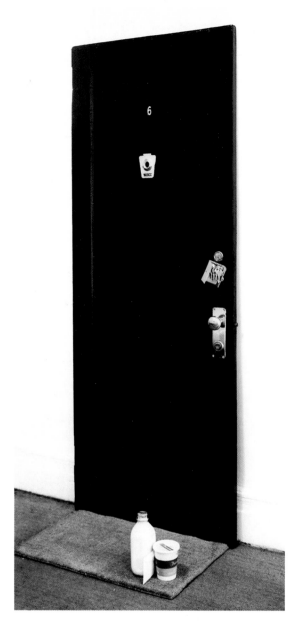

14. Eleanor Antin Portrait of Lynne Traiger 1971 (reconstructed 1995)

portraiture most directly. By using strap-on plastic body parts, including fake breasts, moles, and hairy chests, Sherman makes us see these portraits as images that have been made up, then made to perform like actors in a trumped-up stage set.

During the 1970s, artists such as Adrian Piper, Carolee Schneeman, and Eleanor Antin began using performance as a way to examine a number of feminist issues concerning identity and sexuality, female roles and the inner self.[4] These issues were frequently explored through the invention of personas, a strategy employed by Antin in her mythical characters such as Eleanora Antinova. Some of her earliest works, however, included a number of portraits of specific individuals. A 1970 series, *Portraits of New York Women*, portrayed women such as Margaret Mead, Yvonne Rainer, and Carolee Schneeman through constructed tableaus, a kind of emblematic portrait. Unlike Cindy Sherman, Antin provided us with a stage set, but left the actor up to the imagination of the audience. For her portrait of anthropologist and filmmaker Margaret Mead, Antin employed a director's chair with Mead's name printed on it, field glasses, and an umbrella to shield Mead from the hot sun that she would often sit under while filming.

PLATE 14 One of Antin's most provocative portraits in this series is that of Lynne Traiger, a former publicist for the Museum of Primitive Art in New York and an acquaintance of the artist. Here we see a black apartment door with a bottle of low-fat milk, a container of cottage cheese, and a newspaper sitting on a mat. For New Yorkers, the setting looks quite familiar—it is the entrance to a New York apartment. But what about the keys dangling from the lock? And what about the milk and newspaper, why were they not taken inside? Has the occupant gone inside and forgotten them? Or perhaps she never made it inside? Not only is the viewer left to figure out who Lynne Traiger is, but also what has happened to her. Antin offers us a set of clues we must figure out for ourselves.

Although Chuck Close and Byron Kim are from different aesthetic generations, there is something that binds their work together. Each has investigated systems of perception and representation in seemingly empirical fashion. Chuck Close began making "heads," as he referred to them, in the late 1960s. He was not interested in the traditional aims of portraiture, reproducing likeness or illuminating a "truth" about the subject. His attraction was to the process of painting. Using an approach grounded in the reductivist demands of Minimalism and its experimentations with scale, Close first photographed his subject, then used a grid system to divide the image into a group of equal units, which ultimately comprised the painted whole. His aim, he says, was to "take what I thought was a very Western, that is American convention of all-over-ness that came out of Pollock and was extended to field painting and Stella's black paintings, and overlay that notion on top of the portrait to do away with the hierarchy which says eyes, nose, mouth are important." [5]

Unlike Andy Warhol, who used ready-made publicity photographs, Close photographed the subjects himself in a style suggestive of a mug shot. This was the first of many steps in a process that continually mediated between artist and subject. The reductive grid format, he claims, allowed him to get as much information into the picture as possible. These paintings often reach heights of 12 feet, such as a 1979 portrait of his friend Mark Greenwald. The monumental scale was a deliberate FIG. 15

[4] For an excellent history of feminist art, see Norma Broude and Mary D. Garrard, eds. *The Power of Feminist Art: The American Movement of the 1970s, History and Impact* (New York: Harry N. Abrams, 1994).

[5] Interview with the author, October 1994.

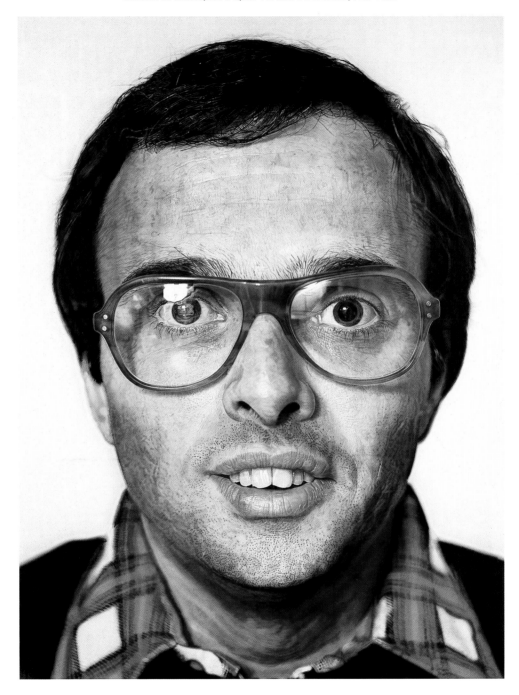

16. CHUCK CLOSE FANNY 1984

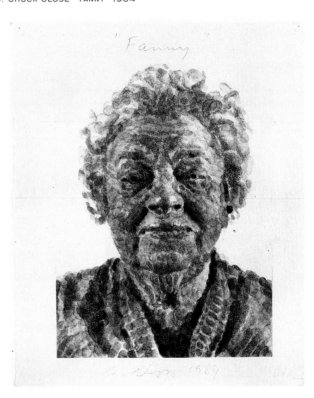

ploy on the artist's part, for "the bigger they are the longer they take to walk by and therefore the harder they are to ignore....they sucker you right up next to the painting....the dichotomy between that big, aggressive, confrontational image and the intimacy is largely what I'm working with."[6] *Fanny* (1984) typifies Close's eventual move away from the cool surfaces of the early works to surfaces that become more emotionally charged, more painterly. The fingerprints which construct the surface function as the ultimate mark, the ultimate evidence of the artist's hand, and the ultimate signifier of identity.

PLATE 16

Bryon Kim explores the notion of surface to include both formalist as well as cultural concerns. Through the metaphorical use of skin color,

Kim challenges stereotypical readings about race, in which people are categorized as black, white, yellow, and red. An ongoing project, *Synecdoche*, involves numerous individual panels, each one a portrait of a specific person's skin color, arranged alphabetically in a grid by the person's surname. Kim's expansive palette of skin reflects the present cultural expansion of once limited thinking about color, as is apparent in the "multicultural" crayons now manufactured by Crayola, in which the single "flesh" crayon has been replaced by a variety of tones. Kim has called *Synecdoche* "a strange project because I am making abstract paintings, but their subject matter is so concrete. In a sense these paintings are representational, even figurative."[7] By using a diversity of colors to represent specific

FIG. 1

[6] Ibid.

[7] Quoted in Thelma Golden, "What's White...," in *1993 Biennial Exhibition*, exh. cat. (New York: Whitney Museum of American Art, 1993), p. 28.

18. BYRON KIM SYNECDOCHE 1992. OIL AND WAX ON PANEL, 204 PANELS, EACH 10 X 8 IN.
COURTESY MAX PROTETCH GALLERY, NEW YORK.

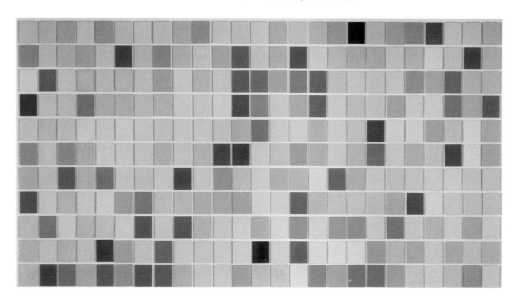

19. BYRON KIM EMMET AT TWELVE MONTHS 1994

people, Kim infuses the painting with a sense of the personal, while at the same time effecting a kind of coexistence between two seemingly disparate conditions—the institutional and the individual. In a very personal work, *Emmett at Twelve Months*, Kim created a portrait of his young son composed of the range of colors he found on the baby's body.

PLATE 19

Portraiture is a container for many things—a signifier of status, wealth, social class, a way to capture likeness, a way to catalogue people. It is also a way in which to represent what has been underrepresented, or not represented at all. For many artists, the portrait, especially the photographic portrait, offers an opportunity to control representation, to influence how the depiction is made and then reinvest it with personal meaning.

Lyle Ashton Harris used some of the conventions of portraiture—ornate furniture and richly colored background (the colors from the Marcus Garvey flag associated with the Black Nationalist Movement) to create scenes for his series *Queen, Alias, and Id*. The title of the series itself reflects the various social roles sometimes played by gay men (queen and drag queen). Harris' project explores these various realities, giving complexity to the term "identity." Harris invites a number of "collaborators," as he calls them—his family, his friends—to participate, and their interactions form the core of his photographic project to reveal something about himself and others. *Queen, Alias and Id: Madonna and Child* features the photographer seated side-by-side with his mother, captured in an extremely tender moment. Harris sees the image as an expression of "a certain aspect of our relationship that gets played out for the camera."[8] If we consider this work in

PLATE 20

conjunction with *Sisterhood*, in which Harris and the artist Ike Ude are wearing makeup and seated in poses similar to those of *Madonna and Child*, yet another image of Harris emerges.

PLATE 21

The entire series has a certain mythological read to it, like frozen passages, each one signifying another moment in a long historical epic scripted by the artist. Many of Harris' themes evolve from Toni Morrison's novel *Beloved*, which chronicles the experiences of Sethe, a woman who carries the psychological and physical vestiges of slavery. *For Cleopatra* features Harris' cousin, and our eye moves immediately to the prominent scar running down the center of her back, something usually hidden under clothes. The scar is from surgery to correct scoliosis, or curvature of the spine. It is a memory she carries with her, much like Sethe carries her memories of slavery and the whip.

PLATE 22

Carrie Mae Weems was deeply influenced by the black tradition in photography as developed by James VanDerZee, a commercial photographer whose studio photographed Harlem's leading residents, and by Roy De Carava. De Carava was a mentor to many younger photographers, and, like him, Weems became committed to creating her own portrayals of her community. Her series *Family Pictures and Stories* (1978–84) is reminiscent of the family photo album. Forty-nine "snapshots" are combined with audiotape recordings of Weems recounting stories from four generations of her family. The series offers two kinds of narrative, the visual and the spoken, and suggests the various ways in which information is retained. Weems has said that the series was prompted, in part, by "The Negro Family: The Case for National Action," the government-sponsored investigation conducted by Daniel Patrick Moynihan in 1965,

FIG. 24

PLATES 25–27

[8] Conversation with the author, January 1995.

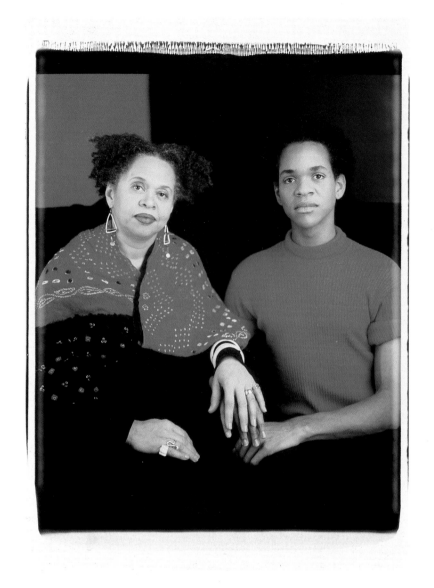

20. LYLE ASHTON HARRIS QUEEN, ALIAS AND ID: MADONNA AND CHILD 1994

21 . Lyle Ashton Harris (in collaboration with Iké Udé) Queen, Alias and Id: Sisterhood 1994

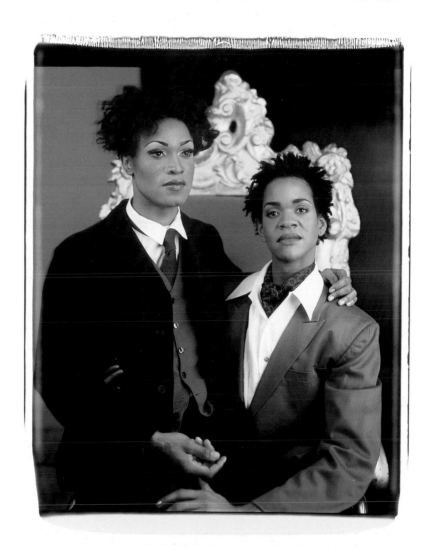

22. Lyle Ashton Harris (in collaboration with Margaret Peggy Aim Nelson)
Queen, Alias and Id: For Cleopatra 1994

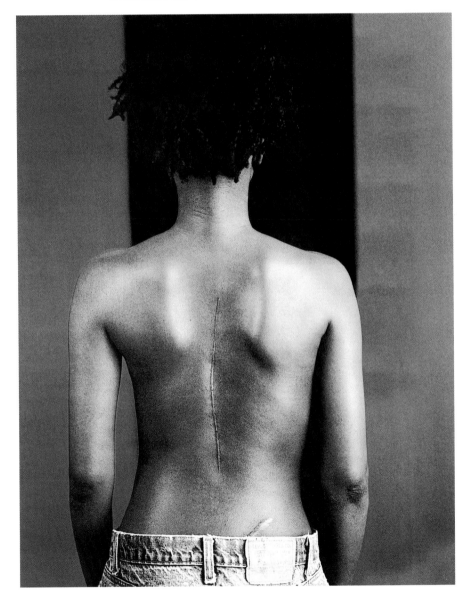

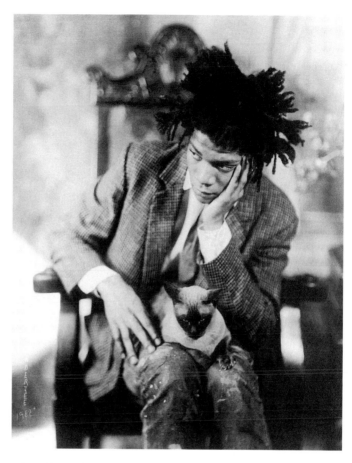

23. JAMES VANDERZEE JEAN-MICHEL BASQUIAT 1981. © DONNA MUSSENDEN VANDERZEE

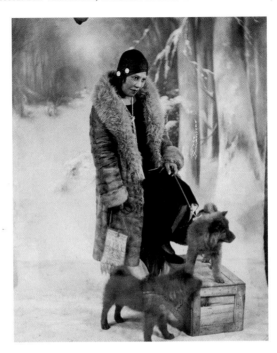

which suggested that black families were in crisis due to their matriarchal structure. As Andrea Kirsh has written, "Carrie Mae Weems tells her own story as a consciously political act, defying inaccurate government sociology."[9] Weems therefore offers a family portrait that transcends stereotype.

Other artists have employed informal narrative approaches to image-making to create collective portraits, such as Billy Sullivan's lush brush-and-ink paintings on paper. These images, a kind of Samuel Pepys version of the New York art and fashion scene, suggest the casual format of the snapshot and blur the lines between who is watching and who is being watched. Sullivan has said of them, "I've always been a voyeur. Who sometimes gets confused and gets involved."[10] This comment

PLATES 29–30

may explain his process: he first takes photographs and makes paintings later, so that he can situate himself in the moment twice.

Artists such as Gary Schneider, Judith Joy Ross, Tony Oursler and even Fairfield Porter bear down on their subjects with a penetrating gaze, but their images remain ambiguous and enigmatic. Alice Neel also looks hard at her sitters, but with rather different results. Neel devoted most of her career to portraiture. The intensity that has come to characterize her work is achieved through bold angular brushstrokes and a deliberate frontal format. Unlike Andy Warhol, whose commissioned portraits were clearly calculated to please their sitters, Neel cares about no other opinion than her own. She has said, "...you know, I never change a

[9] Quoted in Andrea Kirsh, "Carrie Mae Weems: Issues in Black, White and Color,"
in *Carrie Mae Weems*, exh. cat. (Washington, D.C.: The National Museum of
Women in the Arts, 1993), p. 12.
[10] Saul Ostrow, "Interview with Billy Sullivan," *Bomb Magazine*, no. 50
(Winter 1994-95), p. 52.

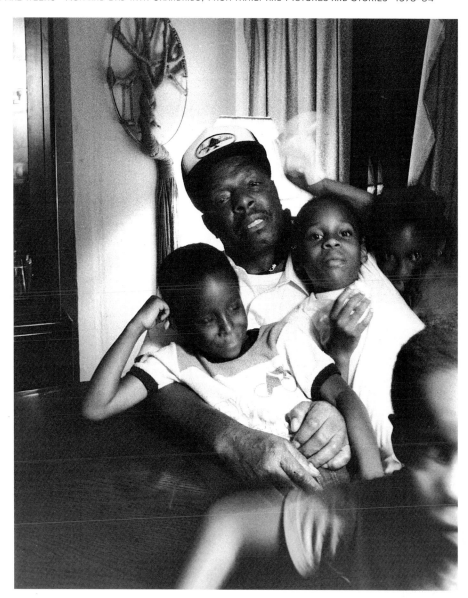

26. Carrie Mae Weems Uncle Kelly and Aunt Esther, from Family Pictures and Stories 1978–84

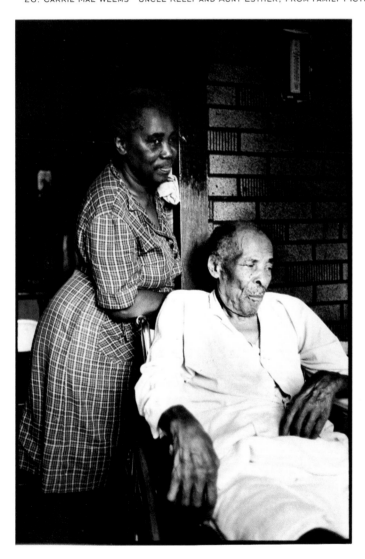

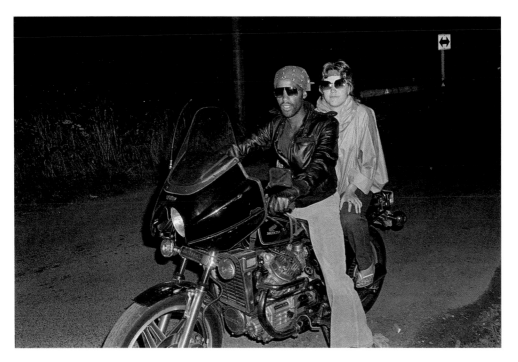

27. CARRIE MAE WEEMS JOSEPH AND LAURIE 1978-84

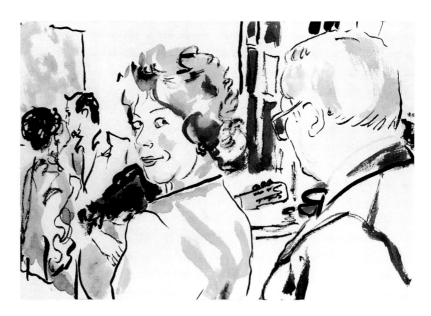

28. Billy Sullivan Lorraine and Herman 1994

29. Billy Sullivan Massimo Me Marina & Greece 1994

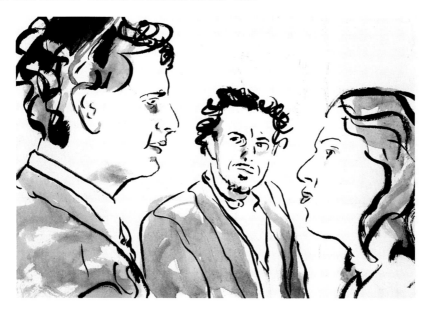

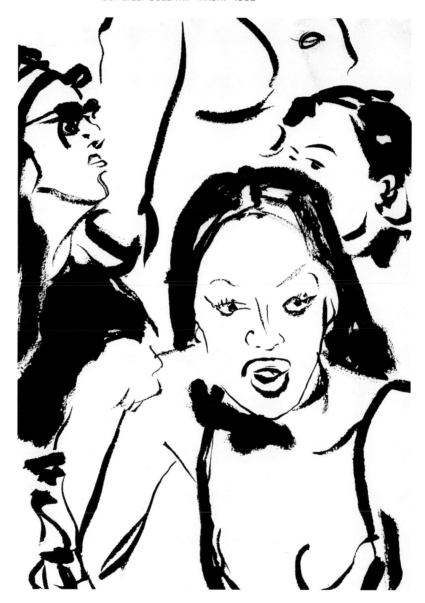

nose because somebody doesn't like it. I just say, Well, you don't like it, so that's it. And I put [the painting] on the shelf."[11] Two portraits, made some three years apart, take as their subject several people with close ties to Long Island's East End, where The Parrish Art Museum is located. A 1970 painting, *The Family*, features the painter Jane Wilson, her husband, critic John Gruen, and their daughter, Julia. Neel recalled: "John Gruen reminded me of a Gypsy father and Jane Wilson looked so much like a fashion model that I was amazed to find out that she had been a fashion model before she was an artist."[12]

PLATE 31

Neel clearly revels in the individuality of her sitters, often accentuating aspects of their features to produce intense character studies. She approached age and sickness with forthright candor, never sentimentalizing, never minimizing. Her 1973 portrait of the Soyer brothers, the painters Moses and Raphael, shows them seated side-by-side, which heightens their identity as twins, and their frailty is apparent.

PLATE 33

Tony Oursler projects video images onto stuffed dummies and other objects, creating hybrid characters that are at once real and inanimate—and that serve to undermine the notion of the self as a unified whole. In *MMPI (I Like Dramatics)* (1994), he explores the ways in which the Minnesota Multiphasic Personality Inventory is used to codify personality. In this diagnostic test, which Oursler calls a "failed attempt at a universal portrait," 550 statements are interpreted by the subject and the responses are clinically evaluated to determine personality characteristics and disorders.

PLATE 39

Gary Schneider levels another kind of penetrating gaze at his subjects, but with an entirely different effect. He produces disturbingly powerful, yet enigmatic portraits that emphasize the elemental nature of photography as a record of the passage of time and light. Using an 8 x 10 camera, Schneider opens the shutter wide and then directs light onto the faces of his subjects with a flashlight to create a kind of landscape of the face. Unlike Neel, however, Schneider does not make any claims for revealing truth about his sitters. Rather, as the critic Lauren Sedofsky suggests, a kind of curious displacement occurs because the result of his process is an emphasis on the face as surface.[13]

PLATES 36–

In his 1970 article, "Speaking Likeness," Fairfield Porter wrote, "Alex Katz said that when you paint a portrait the difficulty is that you have to get a likeness and make the paint go across the canvas. This implies a paradoxical combination: that there is nothing of art in the first necessity, and nothing but art in the second."[14] Denying the paradox, Porter conceived his images as an evocative merging of art and nature, "as analogous representations of the sitter rather than as scientific descriptions, [in the belief] that his formally evocative, interpretative depictions could reveal the individuality of his subject most effectively."[15]

One of Porter's most stunning portraits, *Anne in a Striped Dress* (1967), features the artist's wife. It is also a painting which highlights the ambiguous nature of portraiture. With his studio as the setting, we see a wall with reproductions tacked up on it. To the immediate left of Anne Porter's face is a detail of one of the most enigmatic portraits of all, the *Mona Lisa*. There has always existed much speculation as to whether Leonardo's sitter smiles or not, and one might say the same thing about Porter's. Sitters in Porter's paintings, even children, rarely express any extreme emotion, a device that only serves to heighten the sense

PLATE 3

[11] Quoted in Patricia Hills, *Alice Neel* (New York: Harry N. Abrams, 1983), p. 107.

[12] Ibid., p. 149.

[13] Conversation with Lauren Sedofsky, January 1995; see also her "Gary Schneider's Photographs: Through Glass, Darkly," *Artforum*, 33 (March 1995), pp. 68-74.

[14] Fairfield Porter, "Speaking Likeness," *Art News Annual*, 36 (1970), p. 39.

[15] Richard Brilliant, "Portraits: The Limitations of Likeness," *Art Journal*, 46 (Fall 1987), p. 171.

31 . ALICE NEEL THE FAMILY (JOHN GRUEN, JANE WILSON, & JULIA) 1970

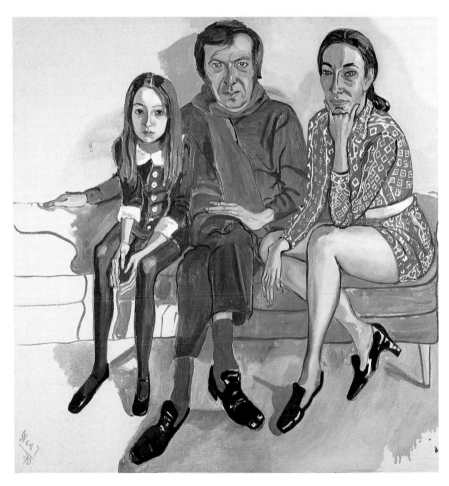

32. MOSES SOYER SELF-PORTRAIT c. 1960

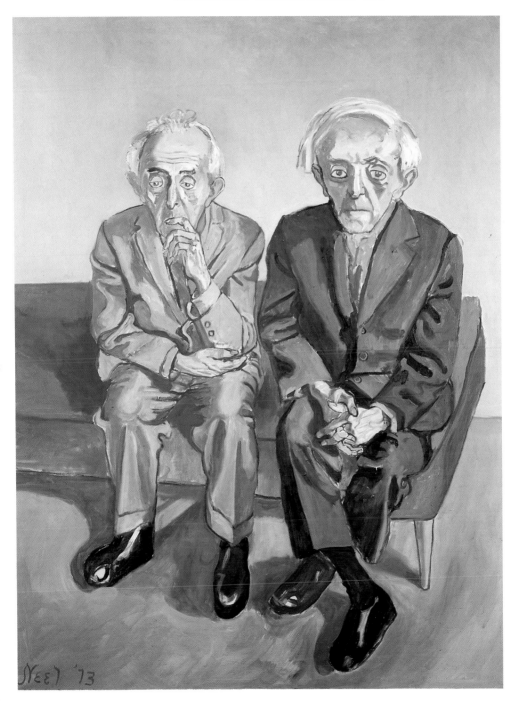

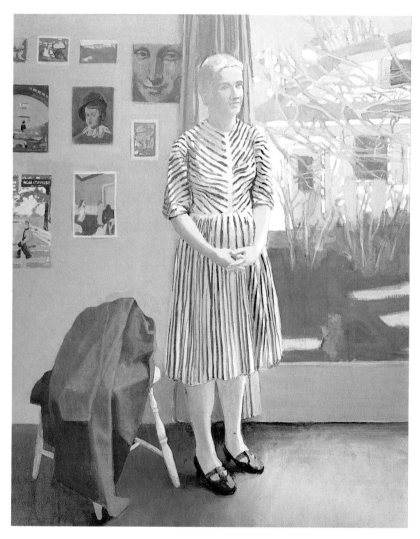

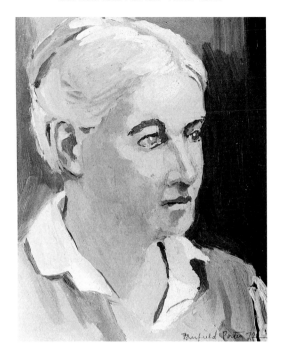

of mystery about the subject. Porter leaves room for viewers to come to their own conclusions: "One understands art by imaginative identification, which is also the way the artist (or scientist, or logician) discovers his subject in the first place."[16]

This painting contains yet another level of complexity, for it meshes the biographical content of sitter and of the artist to further complicate the issue of subject matter. The red Shaker robe on the chair and the dress Anne wears were both family treasures given to Anne by her mother.[17] Among the images pinned to the wall are two references to Porter's political and painterly interests; a reproduction of a Velázquez and the cover of a *Life* magazine featuring Adlai Stevenson. All this information, of course, is held harmoniously in bal-

ance through Porter's carefully crafted composition and subtle shifts in paint.

Historically, portraiture has been a way to commemorate individuals, such as leaders in the worlds of government and business or those wealthy enough to commission a professional artist or photographer. These depictions have tended to show the subjects at their best, like the modern-day publicity photograph, which presents us with a carefully constructed representation. This relationship between public and private, between image and identity, has been a preoccupation of many artists. It can be seen in the word-portraits of Felix Gonzalez-Torres, the celebrity collages of Ray Johnson, the paintings of political figures by Leon Golub (as Maurice Berger discusses elsewhere in

[16] Porter, "Speaking Likeness," p. 51.
[17] William Agee, *Porter Pairings*, exh. cat. (Southampton, New York: The Parrish Art Museum; New York: Hunter College Art Gallery, 1993), p. 8.

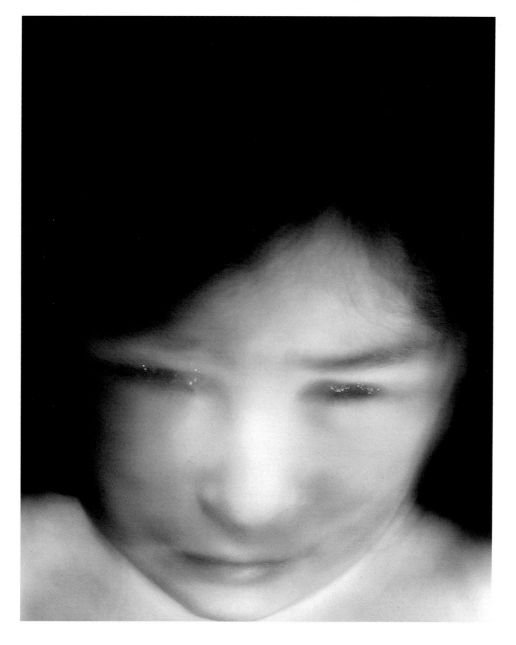

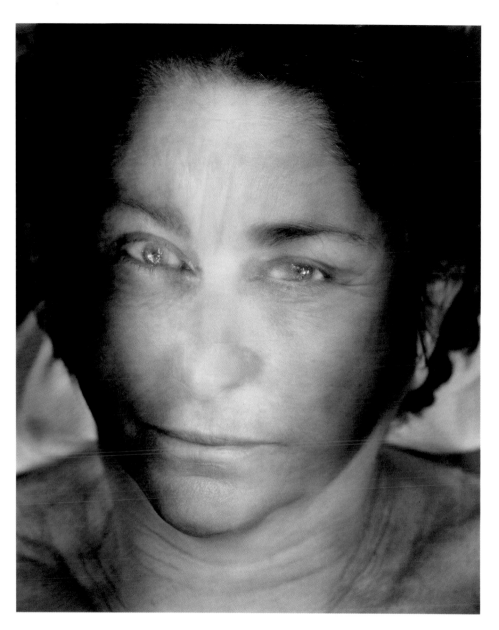

37. Gary Schneider Mirriam 1993

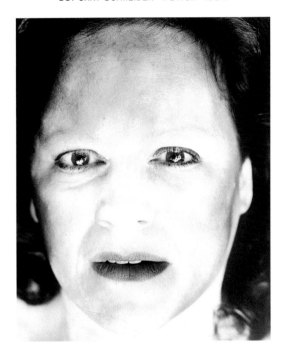

this catalogue), and the celebrity portraits of Andy Warhol.

Throughout his career, Ray Johnson produced an extraordinary body of work that succeeded in casting the notion of identity as a series of riddles and puzzles, but without discernible answers. Beginning in 1955, Johnson used publicity photographs to explore the relationship between public image and private self through portrait collages of such enigmatic public figures as Elvis Presley, James Dean and Marilyn Monroe, an activity he continued throughout his career with subjects ranging from Janis Joplin to River Phoenix. Johnson may be best known for his "mail art," a network of individuals with whom he corresponding using the postal service. Here, individuals were encouraged to add to portraits and other activities leading to images which seemed to be in a perpetual state of change, much like identity itself.

In his portrait collages, Johnson used a number of visual devices to create multiple layers of meaning about a subject, including himself. *Portrait of Michael Arlen*, 1980s, for instance, a PLATE commissioned work, features the device of the traditional silhouette, but covered with an overlay of puzzle-like blocks, which the artist has referred to as "tessarae chunks"—a tessarae is an individual element of a mosaic. *Green*, 1989, is comprised of a PLATE photograph of the artist with its top layer mechanically sanded off, but in which the image is still identifiable. Johnson has collaged over his face a swatch of green carpet from the home of his friend

39. Tony Oursler MMPI (I Like Dramatics) 1994. Mixed media, (performance by Tracy Leipold), dimensions variable. Collection of A.G. Rosen; courtesy Metro Pictures, New York.

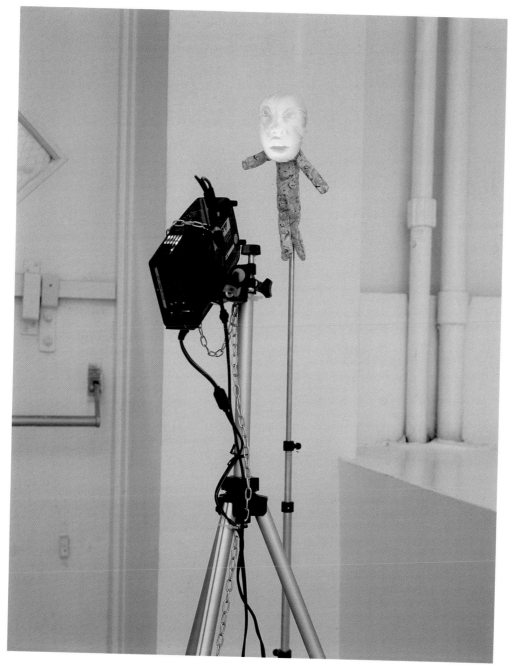

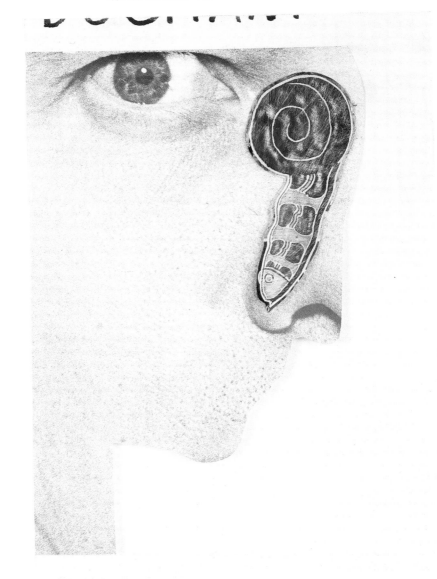

41. Ray Johnson Portrait of Michael Arlen 1980s

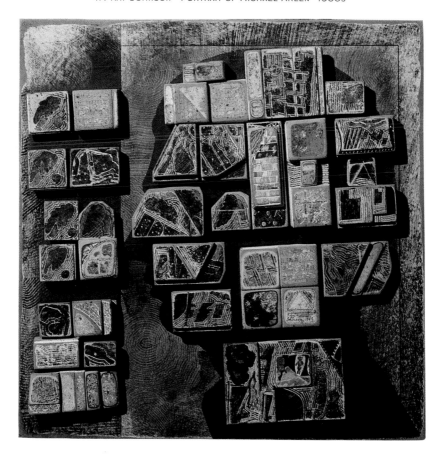

PLATE 40

and the object's owner, Toby Spiselman, producing a mask. *Ducham*, 1977, presents simultaneous portraits of the artist and Marcel Duchamp, clearly showing Johnson's identification with Duchamp's explorations of the self. Johnson has again taken a photograph of himself, this time cut to form the profile of Duchamp, as Duchamp had done in his own self-portrait. That Johnson titles the piece as he does, leaving off the *p*, renders it incomplete—a deliberate metaphor for the ways in which human identity itself resists complete exposure.

No artist has done more to energize the issue of public vs. private identity in contemporary times than Andy Warhol. Once a successful commercial artist, who in the 1950s made "shoe" portraits of movie stars, he possessed a keen awareness of the strategies by which images were crafted for mass consumption, especially through the publicity photograph, where a persona constructed to have the greatest public appeal was sold like any other product. In his work, he connected the dots between Coca-Cola and Marilyn Monroe, between Campbell's soup and Elvis Presley, once remarking that "Repetition adds up to reputation."[18] As is seen in his 1962 painting *Before and After*, Warhol also understood how it was becoming easier than ever to make yourself into the kind of image you wanted to be.

FIG. 43

During the 1970s, Warhol continued to make portraits of public figures and celebrities. He also substantially escalated his commissioned portrait production, leading the art historian Robert Rosenblum to dub him "court painter to the 1970s."[19] For these portraits, however, Warhol did not employ existing newspaper photographs or publicity stills, but rather a Polaroid camera to make his own "publicity photographs." He began by coating the faces of the female subjects with white powder that created an effective porcelain texture, reducing lines, wrinkles and double chins. He performed similar cosmetic wizardry on his male clients. Bob Colacello, once editor of Warhol's

[18] Quoted in Wendy Steiner, "Postmodern Portraits," *Art Journal*, 46 (Fall 1987), p. 174.

[19] Robert Rosenblum, "Andy Warhol: Court Painter to the 70s," in David Whitney, ed., *Andy Warhol: Portraits of the 70s*, exh. cat. (New York: Whitney Museum of American Art, 1979).

UNCLE TOM'S CABIN
Harriet Beecher Stowe

ON A LATE AUTUMN afternoon in 1862, Abraham Lincoln was reviewing battlefield dispatches in his White House office when a small, grandmotherly woman was ushered in. The careworn President looked up and, recognising his visitor's face from newspapers, rose to grasp her tiny hand with his great one. In mixed tones of disbelief and humility, he said softly: "So this is the little lady who wrote the book that made this great war."

The little lady, who scarcely looked capable of fomenting political passions, was Harriet Beecher Stowe. And her book, *Uncle Tom's Cabin*, which portrayed slavery in heartbreakingly human terms, had,

in the ten years since its publication, done more to kindle the national conscience than the stirring sermons and well-reasoned editorials of a thousand eloquent men. *Uncle Tom's Cabin* would come to be regarded as the greatest American propaganda novel—a remarkable achievement, considering the fact that its author had never before published a work of fiction and was virtually unknown in the world of literature.

Harriet Elizabeth Beecher was born on July 14, 1811 in Litchfield, Connecticut. Her father, Lyman Beecher, a minister of the First Congregational Church, was a dynamic figure, full of evangelical fire and liberal principle. Beecher's children were made to understand that they had a reforming mission in the world, and that they were placed on earth to preach what was right. All of them were talented and outspoken; seven earned national reputations in their chosen fields.

Yet even by Lyman Beecher's

There have been many great novels in American literature—works renowned for their exquisite prose, spellbinding plots, or unforgettable characters. But only one can be said to have helped end slavery, start the Civil War, and change the course of America's history: Harriet Beecher Stowe's masterpiece of social reform, Uncle Tom's Cabin.

lofty standards, young Harriet was exceptional. "Hattie is a genius," her father often boasted to friends, adding that he "would give a hundred dollars if she were a boy". The presumption, of course, was that such talent could never reach its fullest expression in one destined to be a wife and mother first.

When Harriet was thirteen, she was sent to Hartford, Connecticut, where her older sister Catherine was headmistress of a private girls' school. By this time Harriet's tendency to bury herself in books had become a matter of concern to her father, who hoped that under Catherine's sensible influence Harriet would get her feet back on the ground. The plan apparently worked well, for at fifteen Harriet was promoted to instructor of composition and rhetoric.

In 1832 she and Catherine followed their father to Cincinnati, Ohio, where Beecher was appointed president of the Lane Theological Seminary. Harriet, now twenty, resumed teaching, but she was homesick for New England and increasingly anxious over her unmarried status. As therapy, she wrote uplifting tales about New England for a local religious publisher. Harriet also resolved to become more sociable, and soon befriended another displaced Yankee, Eliza Stowe, the young wife of Calvin Stowe, a professor at the Lane Seminary. When Eliza died suddenly in 1834, Harriet was as devastated as Calvin. In their shared grief the two survivors found comfort in each other, and in 1836 Harriet became Calvin's second wife.

The marriage proved to be fraught with difficulties. Professor Stowe was, in Harriet's words, "rich in Greek, Hebrew, Latin, and Arabic, but, alas, rich in nothing else." Lazy and self-indulgent, he suffered bouts of depression and was all but useless in a crisis. Most distressing to Harriet, Calvin could never provide enough income to keep his family in even modest comfort.

As the Stowe household began to grow rapidly, Harriet decided to earn extra money by expanding her writing horizons beyond Sunday school tracts. Not surprisingly, Calvin pledged his full support. "My dear," he told her, "you must be a literary woman. It is so written in the book of fate."

But try as she might, Harriet found the chaos of her household ill-suited to a writer's regime. When Calvin received a teaching appointment at Bowdoin College in Maine, Harriet went ahead with three of their five children to set up a new home. After surveying the situation,

she wrote to her husband: "Our expenses this year will come to two hundred dollars, if not three, beyond our salary." The lack of domestic tranquillity notwithstanding, writing was now a necessity.

The story she chose to tell was suggested by her sister-in-law, Katy, in a letter written in 1850, at the height of abolitionist furore over the new Fugitive Slave Law. The law gave bounty hunters licence to hunt down runaways even in northern states. "If I could use a pen as you can," the outraged Katy wrote, "I would write something that will make this whole nation feel what an accursed thing slavery is."

Although Harriet had always

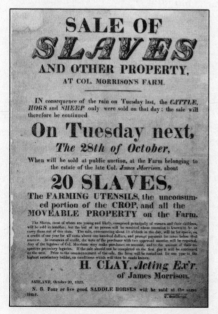

The inhumanity that compelled Harriet Beecher Stowe to write Uncle Tom's Cabin is powerfully illustrated in this 1823 notice for a slave auction. Although the book eventually helped to lead to freedom for slaves, when it was published it did just the opposite for some freedmen. One man in Maryland, for example, was sentenced to ten years in prison for simply possessing a copy.

preferred to write about New England life, she shared Katy's contempt for slavery. From her earliest days she could remember her father preaching against human bondage, "drawing tears down the hardest faces of the old farmers in his congregation". When Harriet finished reading Katy's letter aloud to her children, she paused a moment, then declared in a firm voice: "I *will* write something. I will if I live."

A few weeks later, on a Sunday morning in February, the plot began to unfold. While sitting in church Harriet fell into a trancelike state, a vision of saintly Uncle Tom on his deathbed flashing in her mind. Back home that afternoon, still in a state of dreamy detachment, she found some brown paper and began to transcribe her "vision" into words, working late into the night. When she read the passages to her family the next day, her youngest children wept, one of them saying through his tears: "Oh Mama! Slavery is the most cruel thing in the world." At last Harriet had found herself a cause worthy of a Beecher.

Determined to make her story more than just a sentimental tale, Harriet set out to gather as many realistic details of plantation life as she could. She went to Boston to talk to abolitionists and wrote to Frederick Douglass, a great black leader of the era, for advice.

Harriet expected that the story of Uncle Tom could be told in three or four sketches and be ready within a month. On that basis she sold it for $300 to the National Era, an abolitionist journal. But as she later insisted, she "could not control the story; the Lord himself wrote it". Neither could she contain her passion. "My book, instead of cooling, boils and

bubbles daily and nightly," she explained. Before long the sketches had evolved into a full-length novel.

As the serialised version neared its end, a Boston publisher offered to print 5,000 copies of the story in exchange for 10 per cent of any profits. On March 20, 1852, *Uncle Tom's Cabin* was issued in two volumes. By August, Harriet had already received an astonishing $10,000 in royalties, and before the year was out more than 300,000 copies of the book were sold, causing *Putnam's Magazine* to declare: "Never since books were first printed has the success of *Uncle Tom's Cabin* been equalled; the history of literature contains nothing parallel to it, nor approaching it.

In time *Uncle Tom's Cabin* became the first American novel to sell over one million copies, and it was translated into twenty-one foreign languages. "How she is shaking the world with *Uncle Tom's Cabin*," Henry Wadsworth Longfellow wrote of Mrs Stowe. "At one step she has reached the top of the staircase up which the rest of us climb on our knees year after year." The secret to that ascent was perhaps best summarised by Ralph Waldo Emerson, who noted that the novel spoke "to the universal heart, and was read with equal interest in the parlour, in the kitchen, and in the nursery of every house," putting it on equal footing with the family Bible.

At first, abolitionists expressed disappointment that the book did not denounce slavery more vigorously. But as readership grew and as more and more people were aroused by the issue, Harriet Beecher Stowe became the heroine of the antislavery movement in the North. In the South the book was condemned as "slanderous" and its author branded as "mouthpiece of a dangerous faction which we may be compelled one day to repel with the bayonet." Hate mail, something quite new, began appearing at Harriet's doorstep. She and Calvin were particularly horrified when an envelope arrived containing a slave's severed ear.

With fame and fortune came an endless round of social appearances in the USA and abroad. Everyone wanted to meet the great author with the kindly face and the Yankee twang. Songs were written in her honour, and children greeted her with bouquets of flowers wherever she travelled. The lady who had once found time to write only after the housekeeping chores were finished could now afford a cook and a nursemaid. The Stowes eventually settled in two residences—one in Hartford, next door to Mark Twain, and another in Mandarin, Florida, where, the shy celebrity noted with pleasure, "the world is not."

Harriet continued to write, her small, delicate hand scarcely resting over the next thirty years. She produced a succession of popular novels, poems, and essays. But only one other work dealt with slavery, and none of her writing approached the power—or success—of *Uncle Tom's Cabin*. She also went on the lecture circuit, where, according to one critic, she appeared "a wonderfully agile old lady, as fresh as a squirrel, but with the face and air of a lion."

Calvin, whom Harriet always managed to love in spite of his many eccentricities, died in August 1886. Ten years later, on July 1, 1896, Harriet—having done her duty to her father, her country, and her God—died just two weeks short of her eighty-fifth birthday.

Portrait courtesy of The Schlesinger Library, Radcliffe College. Signature courtesy of Culver Pictures.
Photo on page 3 courtesy of The Stowe-Day Foundation, Hartford, Connecticut.
© The Reader's Digest Association Limited 1995
© The Reader's Digest Association South Africa (Pty) Limited 1995
SWBR-L-HACE

43. ANDY WARHOL BEFORE AND AFTER, 3 1962. SYNTHETIC POLYMER AND GRAPHITE ON CANVAS, 72 X 99⅝ IN. WHITNEY MUSEUM OF AMERICAN ART, NEW YORK, PURCHASE, WITH FUNDS FROM CHARLES SIMON.

Interview magazine, had his portrait made by the artist, later remarking how his rather large nose had been recontoured and his double chin eliminated.

But what happens when the notion of celebrity is removed from a Warhol portrait, when we do not even know the identity of the sitters?

Warhol frequently made several versions of a commissioned portrait for a client to choose from; others were made in the hope that the subject would purchase a finished portrait. Included in this exhibition are several such "unknown" studio portraits by the artist, the identity of the sitters forgotten.

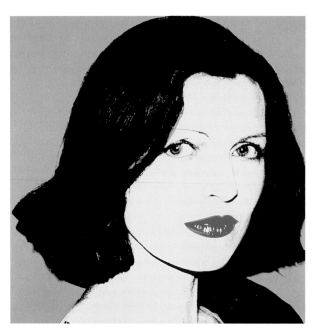

44-46. ANDY WARHOL UNTITLED (UNIDENTIFIED PORTRAIT) C. 1983-86
© 1995 THE ANDY WARHOL FOUNDATION FOR THE VISUAL ARTS, INC./ARS, NEW YORK

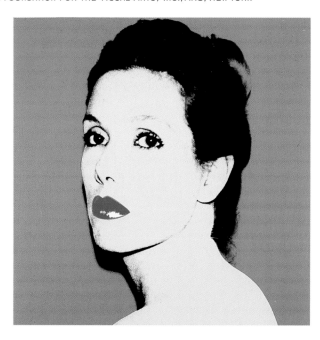

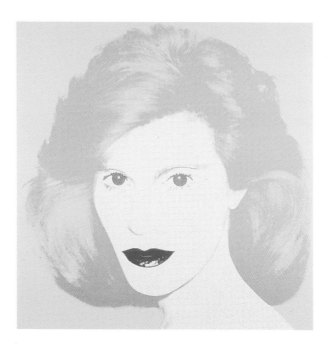

ES 44–46 Although they are striking as paintings, with their lush colors and impeccable graphics, there is a sameness to them. What is most relevant is that they have been painted by Andy Warhol.

Just as there are gaps and spaces in the portraits by Judith Joy Ross and Felix Gonzalez-Torres with which I began this essay, so too there are cracks in the term portrait itself. And many of the artists in this exhibition have helped to make these cracks by undermining conventional notions of the portrait as mere likeness, as revelatory truth, emphasizing the portrait as object, as surface, and as performance. Similarly, the essayists in this catalogue have contributed their own interpretations of "face value."

Although a definition of contemporary portraiture—or a contemporary definition of portraiture—continues to elude us, there is no denying the persistence of the genre. In the later years of his career, Andy Warhol produced a number of images of shadows, camouflage patterns superimposed over his self-portrait, and skulls. Perhaps he FIG. 47 was suggesting that the portrait is our feeble attempt to fight off death itself and capture forever our best performance. It is this aspect of portraiture that may account for its historical durability. For in some sense the portrait is always a metaphor for a collective desire for immortality. While we can view this as fatalism, the act of portraiture is also filled with possibilities, a moment when we convince ourselves that the performance recorded in the image has meaning.

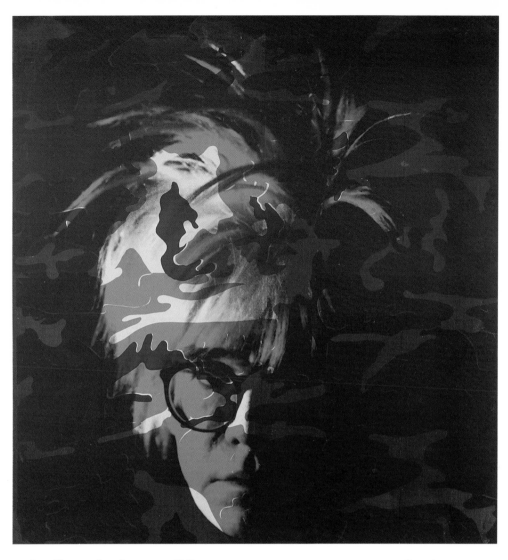

47. ANDY WARHOL SELF-PORTRAIT 1986. SYNTHETIC POLYMER AND SILKSCREEN INK ON CANVAS, 80 X 76 IN.
FOUNDING COLLECTION, THE ANDY WARHOL MUSEUM, PITTSBURGH,
contribution THE ANDY WARHOL FOUNDATION FOR THE VISUAL ARTS, INC.
© 1995 THE ANDY WARHOL FOUNDATION FOR THE VISUAL ARTS, INC./ARS, NEW YORK

48. WILLIAM MERRITT CHASE TWILIGHT PORTRAIT OF THE ARTIST 1887

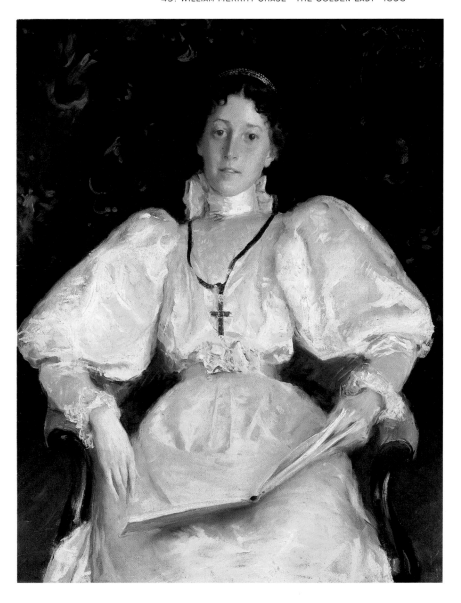

50. Cindy Sherman Untitled # 183 1988

51. WILLIAM MERRITT CHASE PORTRAIT OF HARRIET HUBBARD AYER 1879

52. WILLIAM MERRITT CHASE PORTRAIT OF CADWALLADER WASHBURN C. 1906

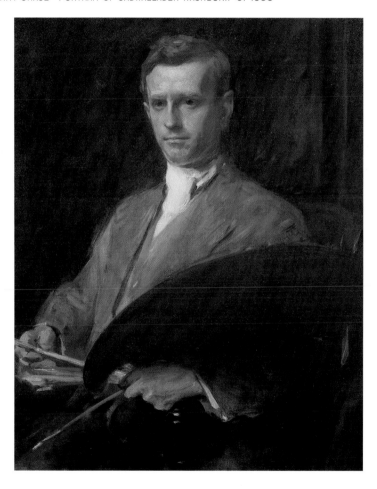

53. WILLIAM MERRITT CHASE ALICE IN THE MIRROR, C. 1897

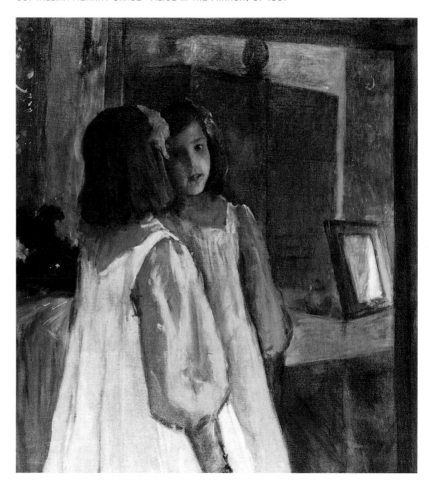

IN PRAISE OF
THE PARTICULAR:

AMERICAN

PORTRAITS

Kenneth E. Silver

The first work of art ever made was a portrait, at least according to Greek legend. A young Corinthian woman, Dibutade, knowing that her beloved would soon depart and wanting something to remember him by, made a silhouette of his shadow cast upon the wall.[1] Right up to our own day, portraiture remains the most widely practiced form of representation, and because of this we are apt to feel both completely at home with it and somewhat dismissive. Can a genre be called artistic that is practiced all the time, everywhere, by almost everyone at one time or another, and by some people—non-artists included—consistently? I'm referring to the portraits of our loved ones which we make with our pocket cameras—-Instamatic, Polaroid, et al. Sometimes these pictures commemorate special events, but even when they do not they become precious anyway, as occasions for commemoration. Since the invention of photography in the early nineteenth century, the potential for a perpetually induced pantheon of ourselves and our intimates has pervaded modern consciousness.

It was not until our own century, nonetheless, that portrait photography truly became everyone's art, at which point we all became not just "subjects" wielding cameras, but perennial "objects of the gaze" as well. Being looked at, like looking, implicates us in a circuit of activity that tends to forgo the present for the future. Photography, and all portraiture for that matter, is

a kind of investment, a layaway plan by which we sacrifice just a little bit of life now for another kind of life to come—one that is frozen, fixed, and, within certain limits, everlasting. Thanks to the pictures we make of ourselves, the party is never quite over. Life may be short, but art—even amateur art!—is long.

Yet the problems which portraiture has had in maintaining its status within the hierarchy of the arts long predates photography and is directly related to its obvious use-value. Its function as a document and a ritual object—in the police file, the college president's office, or the family album—means that its capacity for aesthetic transport (disinterest, in the best sense of the word) is severely restricted. Take the matter of vanity, for instance: what claim to truth may a portrait have that has been commissioned and paid for by the sitter (or the sitter's loved ones or institution), especially when it is made clear that the portrayal *must* be flattering? How can an artist express him or herself when the first requirement is a happy client? This problem is yet further complicated by the ready source of income that portrait making has always represented: a decent living may be earned if one is especially gifted at making sitters look the way they'd like to. Indeed, by the point at which portraiture had sunk to the depths of the hierarchy of the artistic genres in the postwar period (a point to which I will return), it was for precisely this reason: that artists most readily felt their aesthetic

[1] On this subject, see Robert Rosenblum's excellent essay, "The Origin of Painting: A Problem in the Iconography of Romantic Classicism," *The Art Bulletin*, 39 (December 1957), pp. 279-90, and George Levitine's addendum, *The Art Bulletin*, 40 (December 1958), pp. 329-31.

54. ROBERT HENRI LADY IN BLACK 1904

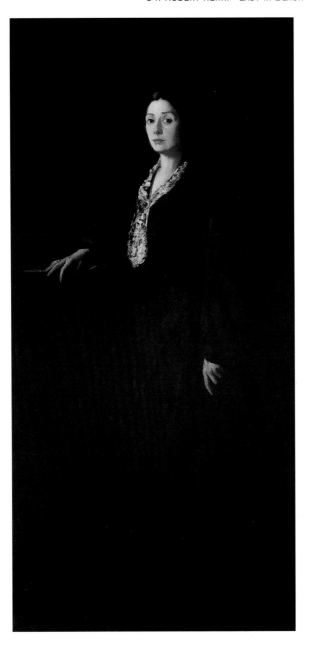

sovereignty diminished by the portrait. Moreover, those who are successful portraitists have usually, at least in their own time, been accused of pandering to the vanity of the elite.

For the painted portrait, the end of the nineteenth and the beginning of the twentieth century was a kind of new Golden Age (as well as a *Götterdämmerung*), and nowhere more so than in America. Probably the coincidence of a great deal of new, industrial money and the reaction against the increasing democratization of photographic portraiture helps account for the era's quantity of important, international portrait painters—Sargent, Boldini, Blanche, Zorn, Helleu, Zuolaga, among many others——and the number of prominent social figures who sat for them. The self-conscious aping of Medici portraits and Baroque portraits of Dutch burghers is very much a part of this glorious last gasp. The Parrish Art Museum—located on the east end of Long Island, one of America's most enduring social enclaves, as well as a venerable artists' retreat—is especially rich in these high style, *fin-de-siècle* portraits. Among the best of the Parrish's collection are those by William Merritt Chase, at the time second only to John Singer Sargent as America's leading portraitist, and a figure of local importance as well, owing to the art school he founded at Shinnecock Hills, close to Southampton. Chase's stylistic range—though limited by the naturalistic conventions of the time, as inflected by Impressionist color and brushstroke and Symbolist mood—is great enough to encompass numerous attitudes on the part of his sitters: from the alert and dainty reticence of Harriet Hubbard Ayer (1879) and the relaxed formality of the richly dressed *The Golden Lady*, painted in Madrid in 1896, to the youthful

ᴛᴇ 51

ᴛᴇ 49

introspection of *Alice in the Mirror*, a portrait of the artist's daughter, and the mature confidence of the handsome artist, *Cadwallader Washburn* (c. 1906), whose palette and brushes, attributes of his vocation, dominate the lower third of the image.

PLATE 53

PLATE 52

Chase's influence, considerable at the turn-of-the-century, is apparent in Lydia Field Emmet's *Portrait of Cynthia Pratt*, which dates from about the end of World War I. Emmet had been not only a Chase student, but also a sitter (he painted her portrait at least twice.[2]) We might say that the young Miss Pratt, in turn, is also doubly blessed by fortune, not only because of her obviously comfortable situation (to judge from her attire and surroundings), but also in having been limned by as able a practitioner as Emmet. The sitter, whose pretty head is tilted at an appealingly inquisitive angle, is the pretext for a highly aestheticized picture, somewhat in the manner of Whistler's portraits of the 1870s and 1880s. This one could be called "Harmony in Turquoise and Ocher," given the thoroughness of Emmet's chromatic exertions: placed before what may be a Japanese screen, Pratt sits upon an upholstered bench in a turquoise silk dress that shimmers with the painterly highlights that Emmet learned to make from Chase, who learned them from Frans Hals, and without which no society portrait of the time would have been considered complete (and which are further emphasized by the scintillas of shoe buckle and furniture-gilding in the shadows below). In her hands, which rest on her lap, Cynthia Pratt holds two strands of beads, turquoise and amber, which also echo almost precisely the plumage of the splendid parrot—a kind of guard-bird, as it were—perched above her head.

PLATE 55

[2] The Brooklyn Museum owns a portrait of c. 1893, and another portrait was apparently in a private collection, although I do not know its current whereabouts. See *William Merritt Chase (1849-1916)*, exh. cat. (Santa Barbara: The Art Gallery, University of California, 1964), n.p., no. 31.

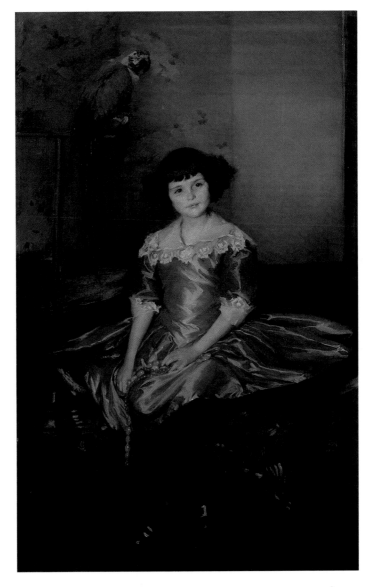

56. HOWARD CHANDLER CHRISTY PORTRAIT OF SAMUEL LONGSTRETH PARRISH 1924

PLATE 54

Nearly the exact opposite of this coloristic tour de force is Robert Henri's *Lady in Black* (c. 1904), a stark and imposing picture of his wife, which traces its artistic lineage to, among others, Thomas Eakins' comparably solemn, no-nonsense portraits. Henri entered the Pennsylvania Academy of the Fine Arts in 1886, the very autumn that Eakins was relieved of his teaching duties, although his influence was still strong on the student body.[3] Yet there is a theatrical quality to *Lady in Black*, an updated Baroque reliance on chiaroscuro, which cannot be accounted for in the American context; it must be found in the art of Hals, Velázquez, and the early Manet, all artists with whom Henri reacquainted himself on his second trip to Paris in 1895.

Despite this flowering of portraiture, the genre went into a general decline in popularity among painters and sculptors from the time of the Impressionists on. Portraiture came less and less to occupy a central place in the œuvre of most self-conscious modernists; it became more a pursuit apart, a product of "portrait painters" per se, that is, those with few avant-garde ambitions. Not only had Impressionism's emphasis on landscape helped to devalue the Academy's prioritizing of the human figure, but increasing interest in abstraction, with the non-referential model of music as its touchstone, made the specificity of portraiture seem old-fashioned. After all, among the goals of abstract art from the very beginning had been a spiritual quest, akin to Eastern philosophy, of transcending material concerns in general and individual ego in particular. Kandinsky and Mondrian come to mind, neither of whom, except early in their long careers, ever made portraits or even invoked the portrait genre by way of refer-

ence. In its extreme form, this anti-individualism may be located in the political and aesthetic ideology of the Constructivist artists of the Russian Revolution, "the people" replacing any person in particular, and pure form—usually boldly colored and simple in geometry—replacing mimesis.

Several other factors pushed modernism away from portraiture, including the aforementioned medium of photography, which haunts the portrait's subsequent history. So good is the *camera lucida* at representation that artists recognized, early on, that they had to find other rationales, and other sources of revenue, if they were going to continue to paint and sculpt. Rather than compete with the camera at seizing likenesses, the modern artist, it was generally agreed, should concentrate on the frankly imaginative, or constructed, or conceptual, aspect of the chosen medium. But this distancing from the empirical was also more than a rationale—it was an economic fact: the rise of the art dealer—who functions, for better or worse, as the intermediary between artist and collector—pushed creators further and further from the actual source of their revenue. While this has obviously meant a great deal of increased freedom, and free time, for the artist, it has also diminished the impetus, and the occasions, for portrait commissions. Perhaps not surprisingly, memorable portraits of art dealers, as distinct from other kinds of patrons or collectors, proliferate in the twentieth century. Among these must be counted Picasso's portraits of numerous Parisian dealers, including Berthe Weill, Ambroise Vollard, Daniel-Henry Kahnweiler, and Leonce Rosenberg; both Otto Dix's and Jules Pascin's portraits of the dealer Alfred Flechtheim of Düsseldorf; Modigliani's portraits of Paul Guillaume and Leopold

[3] William Innes Homer, *Thomas Eakins: His Life and Art* (New York: Abbeville Press, 1992), pp. 186–87.

Zborowski; Francis Picabia's portrait of Alfred Stieglitz (and Peggy Bacon's small portrait sketch of Stieglitz in the Parrish collection); David Hockney's portraits of John Kasmin; George Segal's portrait of Sidney Janis; and Robert Mapplethorpe's portraits of Holly Solomon.

PLATE 57

Portraits, then, did not altogether disappear among modernists, except for those who made purely abstract art, like the American Action painters (and even Pollock and de Kooning, from time to time, made works that bordered on portraiture). Indeed, even at the height of Abstract Expressionism's popularity—and portraiture's nadir—there were figurative painters who insisted on making portraits, and did so at the cost of being taken seriously, at least for a good while, among the critical establishment. The Parrish's collection includes a number of portraits by these artists, like the talented "academic" painters Walter Stuempfig (*Tony as a Bullfighter*) and Aaron Shikler (*D. Levine on His Way to Fort Putnam*, 1957), as well as the more "modernized" figuration of Larry Rivers (*Boy in Blue Denim*, a portrait of the artist's son, 1955) and Fairfield Porter (*Anne in a Striped Dress*, a portrait of the artist's wife, 1967). Alice Neel's portraiture must be situated somewhere between expressionist (in the liberties it takes with proportion and line) and folk art (in the touching "candor" that pervades the work). Neel was an important figure for the legitimacy that was ultimately granted to these indigenous American "Intransigents," as was Leon Golub, whose career

PLATE 58
PLATE 59
PLATE 61
PLATE 34
PLATES 31, 33

58. WALTER STUEMPFIG TONY AS A BULLFIGHTER, C. 1955

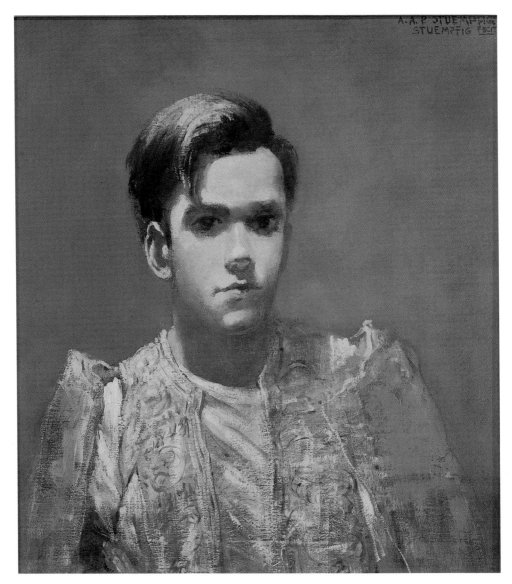

59. Aaron Shikler D. Levine on His Way to Fort Putnam 1957

60. FAIRFIELD PORTER FRANK O'HARA 1954

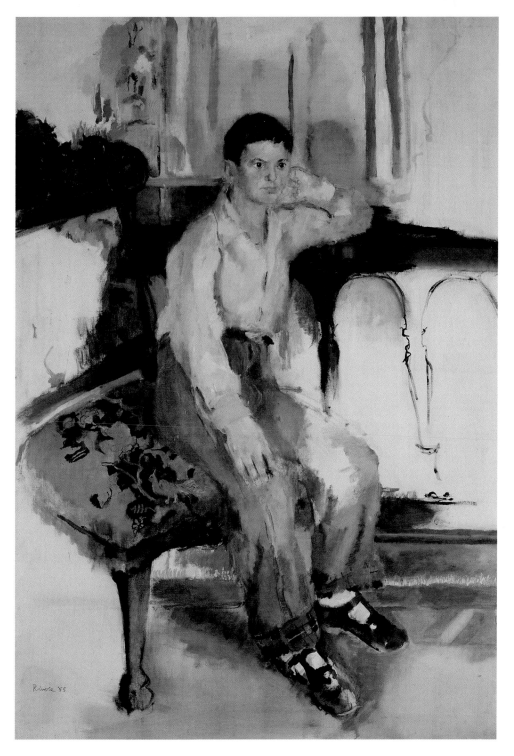

61. LARRY RIVERS BOY IN BLUE DENIM 1955

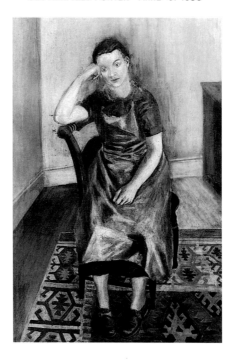

PLATES 66–68 did not really take off until the 1970s. His portraits of Nelson Rockefeller are as contrary thematically as they are stylistically: a genre of anti-official portraiture rendered in a manner that is equal parts photojournalism (their source) and painterly technique (their formal result).

Finally, among the American holdouts against postwar abstract painting, Alex Katz has surely achieved the widest recognition. Evolving from a style closely modeled on the art of Milton Avery in the mid-1950s, Katz worked his way toward a curious, and highly original, cartoonish classicism, part Piero della Francesca and part Juicy Fruit gum (and this was still several years before the advent of Pop Art). His cut-out, painted portraits, like that of artist-poet-critic Frank

O'Hara and of art historians Rainer Crone and David Moos (1991), remove the sitters entirely PLATE 6 from a context, allowing them to enter our environment as sculpture might.

By the 1970s, in the wake of Pop Art and Minimalism, and with the advent of Conceptual art, the formalist aesthetics of abstract painting (and its attendant theory, as expounded by critic Clement Greenberg) were being contested on many fronts. Among the most straightforward critiques of Greenberg's teleologies were those offered by Realist painters such as Philip Pearlstein, Sylvia Sleigh, and Chuck Close, whose embrace of illusionistic representation, and of portraiture, among other genres, was about as direct a slap at pure, abstract reductivism as one could make.

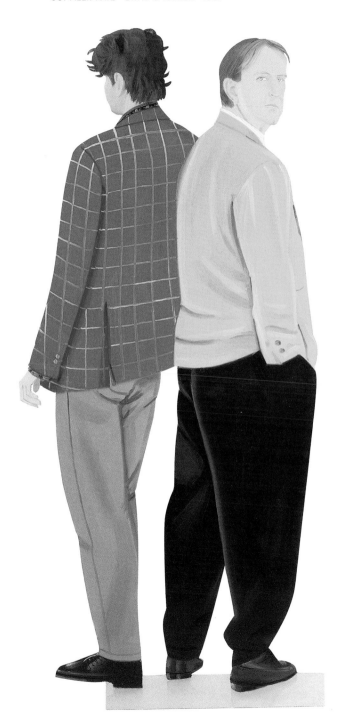

64. ANDY WARHOL THE AMERICAN MAN—WATSON POWELL 1964.
SILKSCREEN INK ON SYNTHETIC POLYMER ON CANVAS, 4 PANELS, EACH 23⅛ X 32⅛.
DES MOINES ART CENTER, GIFT OF WATSON POWELL, SR.

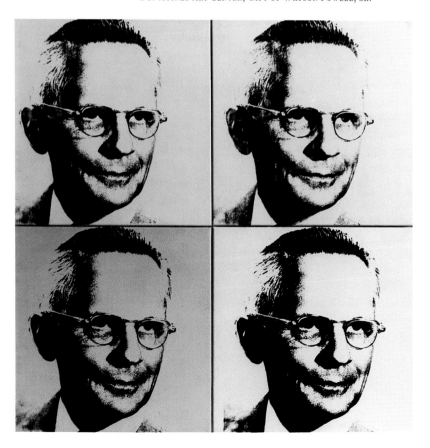

PLATE 16 Chuck Close's *Fanny* (1984), a portrait of his mother-in-law, is an amalgam of many of the offending post-abstract tendencies, from its photographic source and iconic format to its remarkable technique, which returns art to manual labor in the most literal way: Close uses his own fingerprints (with their criminal associations!) to "flesh out" the modeling, so that his wife's mother's face is at once a record of her appearance and a composite trace of her son-in-law's gropings.

Andy Warhol, who made numerous portraits of his own mother, Julia, became a working portraitist in the 1970s. While he had, of course, made many photographic silkscreen portraits of movie stars and media figures in the 1960s (Marilyn Monroe being perhaps the best known of these), only occasionally during the Pop years had he executed private commissions: the portraits of Ethel Scull, based on strips of photo-booth pictures (now in the Whitney Museum of American Art, New York), and of Watson Powell, which often appear with the title *The American Man* (four of FIG. 64 them are now in the Des Moines Art Center), are early exceptions in Warhol's gallery of the already-famous. By the next decade, though, Warhol had become the William Merritt Chase (or Sargent or Boldini) of his day, ever on the lookout for a choice commission, ready to produce a painterly silkscreened photographic rendition of whoever was willing to pay the price for a bit of artistic permanence (although, in fact, many of Warhol's portraits were executed gratis). Surprisingly, part of Warhol's portrait œuvre now shares a fate with similar bodies of work in the distant past, a fate that should have been, but probably was not, predicted: we do not know the identity of any number of the people he painted. The Warhol Foundation possesses a quantity of these portraits-of-the-unknown-sitter, which The Parrish Art Museum is the first to exhibit in "Face Value". Yet PLATE 65 again, Warhol's prediction of "fifteen minutes of fame" for everyone seems to have its objective correlative: like those "anonymous" portraits that long ago entered the history of art despite their namelessness, these Anybodies (some of whom probably never paid for their pictures, and hence Warhol held onto them) may yet become Immortals.

But something very different was also happening in those now distant years following the decline of Abstract Expressionism. Biography, and autobiography, were starting to be reasserted as an antidote, oddly enough, to the Death of the Author. I am referring, of course, to Roland Barthes' widely read 1968 essay of that title, where the French critic gave voice to an attitude and an artistic stance that had been in the air for quite a while. According to Barthes, it is culture that writes *us*, not the other way around, so that the author's text (or, for our purposes, the artist's work) is never original, never the expression of a passion, or a feeling, or an impression, but is, of necessity, a pastiche of borrowings, "a multi-dimensional space in which a variety of writings, none of them original, blend and clash."[4] Needless to say, without such a recognition of our cultural permeability, we cannot imagine the *papiers collés* and photomontages of Picasso, Braque, Kurt Schwitters, or Hannah Höch, nor Fellini's *8½* or Nam June Paik's video sculpture.

The problem was not Barthes' obviously salutary assertion that art should be taken on its own terms, and his protest against the reign of biography in literary or art criticism (although it

[4] Roland Barthes, "The Death of the Author," in Stephen Heath, ed., *Image, Music, Text* (New York: Noonday Press, 1990), p. 146.

should be said that, at least in the U.S., this kind of simple-minded confusion of the artist and the work of art was no longer in vogue by 1968); nor was it Barthes' equally helpful summarizing of the need for a post-Freudian and, implicitly, socially engaged, criticism and art history. But in killing the author (in the name of the "reader"), it was the critic (a critic not unlike himself, it must be said) who was the beneficiary—despite Barthes' specific claims to the contrary. Can anyone doubt that we live, for those who care, in the Era of the Critic?

Yet it was possible, as a group of feminist artists, critics, and art historians recognized, to turn the tables on "authorlessness" and proclaim instead the birth of authors—in the plural, and in the feminine. After all, who can give up what they don't already possess? What good is authorlessness to those who have known, more or less, only *power*lessness? No one who's been "anonymous" for as long as anyone can remember, like the women who sewed American quilts, can imagine namelessness as a new dispensation. The feminists' concern was not a withering away of artists. Their goal was to reclaim forgotten women authors (artists) of the past and, at the same time, ensure the "birth" and nurture the well-being of women artists in the present. This goal often involved strategies of portraiture. The collaborative work known as *The Dinner Party*, a sculptural project of 1974-79, organized and directed by Judy Chicago, one of the founders of the Feminist Art Program at CalArts (California Institute of the Arts), was just such an effort at retrieval: 117 "portraits" of great women of history, here identified by their attributes of vocation, were gathered at a triangularly shaped table. In the same period, Anne Sutherland Harris and Linda Nochlin organized a traveling exhibition for the Los Angeles County Museum of Art, "Women Artists: 1550-1950," which served to resurrect myriad women author-artists.[5] (It is interesting to note that Nochlin was also a key critic and historian in the revival of realist painting, whose own portrait was painted by both Alice Neel and Philip Pearlstein.)

Indeed, we might see both Maya Lin's *Vietnam Veterans Memorial* (1982) and the *AIDS Memorial Quilt* (begun in 1987) as works of group portraiture that grew out of this same post-1970, anti-abstract attitude, where the emphasis is on proper names, particularities, and specifics, and in which two powerful, deeply moving portraits of the dead are given monumental, collective, participatory form. In the decision to inscribe the name of every American who died in combat in Vietnam on the walls of Lin's monument, and to ask every survivor who cared to, to sew an emblem of his/her deceased loved ones for the AIDS memorial—the proper title of which is, in fact, the *NAMES Project Quilt*—a position was enunciated, we might say, in relation to portraiture, to wit, that it is in specificity that memory is most poignantly preserved. No tombs to unknown soldiers or anonymous quilts here. These collective memorials, which recognize a commonality of fate, insist that one is both part of a larger entity and distinct—unique—at the same time.

This is not to imply, however, that feminist-informed art, or art in general, has been one great group endeavor, lacking in individual artists or more personal kinds of portrait making in the last few decades. To the contrary, Eleanor Antin, a West Coast feminist artist, has been trafficking in self-portraiture (in sculpture, performance, and photographed documentation) since the 1970s, PLATE

[5] See the excellent new book edited by Norma Broude and Mary D. Garrard, *The Power of Feminist Art: The American Movement of the 1970s, History and Impact* (New York: Harry N. Abrams, 1994).

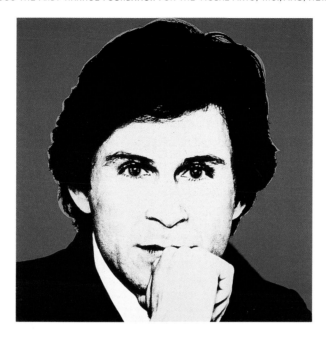

inventing, among other things, new historical "selves," including the Russian ballerina Eleanora Antinova and the "Angel of Mercy" Eleanor Nightingale. Hannah Wilke (whose *Intra-Venus* series, is discussed by Max Kozloff in this catalogue) made nude, photographic self-portraits, decorating her body with various accessories, including wads of chewing gum, hair rollers, and a man's necktie.

In fact, photography has become the preferred medium for self-portraiture in the last decade, and much of the work, in typically postmodernist style, follows in the path forged by artists like Antin and Wilke, that of the doctored-up picture. Beginning with her *Untitled Film Stills* series, Cindy Sherman has been making portraits of herself in constructed personas for nearly fifteen years, continually pitting the artifice of her means against the documentary quality of her medium (and in the process returning to a kind of narrativity that flourished in turn-of-the-century pictorialist work, although now with wit and irony). With Sherman, it is easy to see the influence that feminism, and its questioning of female roles and appearance, has exerted; indeed, owing in large part to feminism, portraiture itself—as a procedure and an ideological project—has been problematized for artists in general. For instance, Lyle Ashton Harris' photographic portraits of himself, his family, and friends manifest two challenges at once: to a tradition of self-portraiture that would hide one's vulnerabilities (creating a more palatable and glamorous public image) and to an equally venerable tradition of self-revelation

PLATE 83

PLATE 13

PLATES 20–22

that would refuse theatricalization and fetishize personal suffering. Harris depicts himself, literally, as a "black queen," at various points wearing makeup, tulle skirts, and sitting, appropriately enough, upon a throne. As it has been for so many feminist artists as well, self-portraiture for Harris involves taking the means of production into one's own hands, and the result is as much a record of the process as an accounting of results.

Lately, portraiture has taken a particularly Conceptual, or rather neo-Conceptual, turn in PLATE 7 American art. Both Felix Gonzalez-Torres' recent portraits and those of Byron Kim are faceless; although the human countenance has almost universally been the most obvious sign of the individual (as distinct from the group), it needn't be so. For Gonzalez-Torres, who has often used the cool strategies of Minimal and Conceptual procedures as lenses through which he refracts hot subjects like AIDS, love, and death, the portrait may be a recital—a kind of biographical ticker tape—of the salient moments in his sitter's lives. Obviously, no two people have experienced the same series of events, in just the same way, any more than they share fingerprints. For Kim, who has also used supposedly neutral, Minimalist grids for such non-formalist subject matter as racial typologies, the birth of his son is the occasion, as for many artists before him, for a portrait. *Emmet at Twelve Months* PLATE 19 (1994), though, will disappoint those looking for chubby infantile legs, surprised baby smiles, or pensive old-before-his-time expressions. Instead, Kim gives us a cool, gridded record of twenty-five rectangles in the life of his son, each the chromatic transcription of some part of Emmet's body. While this approach seems both oddly clinical and hyper-aestheticized, it has the obvious virtue of all good documentation—specificity: no other baby in the world quite displays Emmet's corporeal palette; there is no other boy like Emmet. But, of course, this gets to the heart of our persistent desire, our endless need, for portraiture—it is not just a picture "of" someone we are making, it is a picture of our looking at them. Even when the adored objects of our gaze have departed, we never forget what it *feels* like to look at them. That is what the portrait gives us, the purest sense of subjectivity in relation to another that we know.

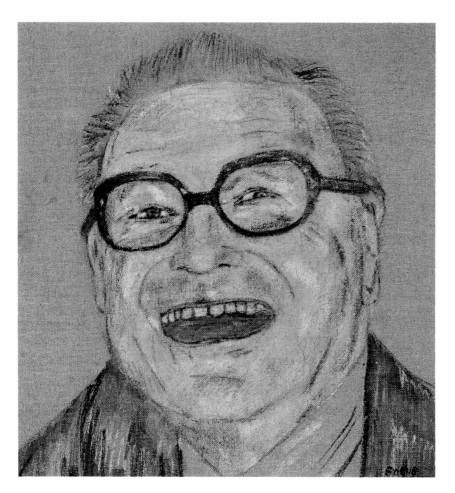

66. LEON GOLUB PORTRAIT OF NELSON ROCKEFELLER (1976) 1976

MAKING FACES

<div style="text-align:right">*Maurice Berger*</div>

My gaze slid by chance towards the massive mirror hanging in front of us and I uttered a cry: in this golden frame our image appeared like a painting, and this painting was marvelously beautiful. It was so strange and so fantastic that a deep shiver seized me at the thought that its lines and its colors would soon dissolve like a cloud.

—LEOPOLD SACHER-MASOCH, *Venus in Furs*

There is something both extraordinary and unsettling about Leon Golub's portraits of former New York governor and U.S. vice-president Nelson Rockefeller. Rockefeller's face, from self-possessed youth to sometimes somber, sometimes cantankerous middle-aged man, is haunted in these paintings by an almost theatrical mannerism. Even as we begin to imagine what the man might have been like as a person, we are confounded by his odd, almost exaggerated expressions. Is he mugging for the camera, we wonder? Or is he making faces in a mirror? In one image, for example, he is shown with his lips tightly closed, his steely eyes narrowed almost to slits, a pose that reads both as arrogant and alluring; in another, his broad, clean jaw has unfurled into expressive jowls, his eyes are filled with light, his mouth is opened in a jolly grin. A new, friendlier Rockefeller seems to have emerged in this image.

In a certain sense, these portraits, appropriated as they are from the media, catalogue the various phases of Rockefeller's struggle to find his public persona. This struggle was especially difficult for a politician whose politics were often a mass of contradictions: he was a liberal Republican in a conservative age; a skilled politician whose clumsy management style resulted in one of the deadliest prison insurrections in U.S. history; a sophisticated patron of modern art who commissioned some of the ugliest state office buildings and educational facilities in the country. Rockefeller walked a fine line between the noblesse oblige of the very rich and the slumming of a man who pretended to be just another guy—an unconvincing paradox that contributed to the failure of his three attempts at the Republican nomination for President. Ultimately, these portraits capture Rockefeller's almost tragic inability to construct a convincing and reassuring public image. Whether on the pages of *The New York Times* or in Golub's reinterpretations, Rockefeller's face appears to freeze into a mask that belongs to no one, not even to him.

These portraits, tentative and unmoving as they are, also capture something more general and fundamental about the political portrait: whether dynamic or mundane, such images are not about reality per se but about the ways in which reality and its representations are manipulated, both by the media and the sitter, into images meant to move, persuade, and convince. Indeed, the photograph itself will always be innately limited in its ability to convey meaning: without a caption, a

ES 66–68

LATE 68

LATE 66

67. LEON GOLUB PORTRAIT OF NELSON ROCKEFELLER (1941) 1976

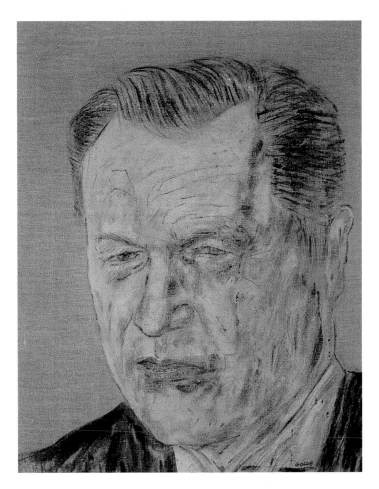

68. Leon Golub Portrait of Nelson Rockefeller (1969) 1976

What in one instance operates as an official, and hence celebratory, portrait of a public figure, can in other hands reemerge as a tool of ridicule or defiance. Without its slogan, "Vote McGovern," for example, Andy Warhol's poster for the presidential campaign of George McGovern in 1972 would FIG. 70 appear to be no more than an oddly colored, somewhat unflattering version of a widely disseminated press photograph of Richard Nixon. Charged by FIG. 69 this provocative juxtaposition, however, the smile on the face of a popular president may remind us more of the smirk of "Tricky Dick," the Nixon who exemplified political manipulation and deceit.

Although photographic historians and cultural critics have turned their gaze on the subject of the political portrait, it is ironically Golub's paintings of famous men that constitute one of the most nuanced examinations of how media images construct meaning. Through the very process of disassociating portrait images from their original sources, Golub has dramatically caught a group of well-known political figures in the act of shaping their political personas. These paintings, executed from 1976 to 1979, consist of serial images of male political figures who were important to Golub and to the world at large. A distinct departure from his signature style, in which monumental and generic male figures enact scenes of human violence and suffering, the portraits depict specific subjects in relatively subdued poses. As Golub observed:

> One of the GI's in [my] *Vietnam III* [painting]...had the appearance of the young Gerald Ford. This accidental resemblance spurred my interest in making portraits of political leaders, their look, their "skin." I made approximately 100 portraits...on such subjects as [Leonid] Brezhnev, John

heading, an institutional context, such images will always remain "stuck in the approximate."[1] Ultimately, while the mechanical processes of photography reproduce reality, other devices, from the caption to the conventions of composition, posing, framing, and point-of-view, allow the photograph to incorporate ideological meaning.[2]

The idea of the image as a vehicle for constructing social meaning would appear to have particular relevance for the subject of political portraiture. One could argue that the political portrait always sets up the subject through formal, stylistic, and linguistic conventions in order to lift it out of the realm of the approximate and into the world of the specific. Such representations of the human face, then, are particularly dependent on various internal and external devices to identify and define their subject, attitude, and ideological position.

[1] Walter Benjamin, "A Short History of Photography," trans. Phil Patton, *Artforum*, 15 (February 1977), p. 51. For more on Benjamin and the issue of photographic context, see Victor Burgin, "Photographic Practice and Art Theory," in Burgin, ed., *Thinking Photograph* (London: Macmillan, 1982), pp. 82-83.

[2] In support of his thesis, Walter Benjamin paraphrases an observation by Bertolt Brecht: "...less than ever does a simple *reproduction of reality* express something about reality. A photograph of the Krupp works or of the A.E.G. reveals almost nothing about these institutions. The real reality has shifted over into the functional. The reification of human relations, for instance in industry, makes [mere reality] no longer revealing. Thus in fact it is [necessary] to *build something up*, something artistic, created"; Benjamin, "A Short History of Photography," p. 51.

70. ANDY WARHOL VOTE McGOVERN 1972.
SCREENPRINT, 42 X 42. © 1995 THE ANDY WARHOL FOUNDATION FOR THE VISUAL ARTS, INC./ARS, NEW YORK

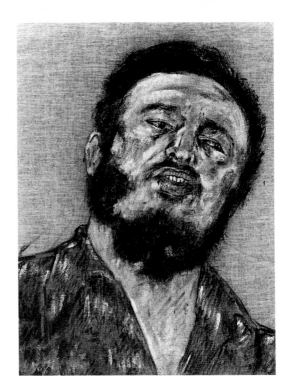

71. Leon Golub Fidel Castro V 1977.
Acrylic on linen, 29 x 22. Collection of Ulrich Meyer and Harriet Horwitz.

72. Leon Golub Francisco Franco (1951) 1976.
Acrylic on linen, 21 x 17. Collection of Ulrich Meyer and Harriet Horwitz.

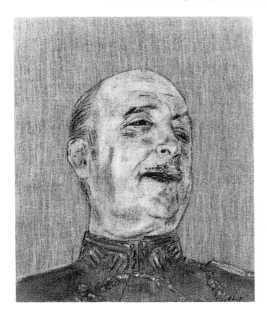

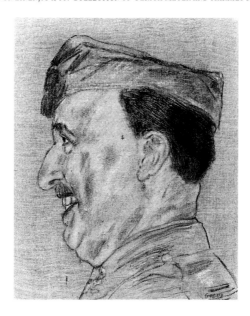

Foster Dulles, [Augusto] Pinochet, Zhou en-Lai, Mao Tse-tung, Francisco Franco, Henry Kissinger, Nelson Rockefeller, Ho Chi Minh....For the most part [I painted these men] not as good guys, not as bad guys, but men who have political power in their hands. What the hell do they look like? How do they come on? I tried to make them as lifelike as possible, to bring out their "look."[3]

The content of these paintings may be specific, but there is something generic about them as well. Through various conceits of posing and point-of-view, these images rehearse a range of rhetorical tropes that have by now become conventional in the media and the arts: Franco, an elegant military cap perched on his head, is shown in stark profile, a direct allusion to the aristocratic FIG. 73 conceit of the strict profile portrait. Another depiction of Franco, in military uniform with his head thrown back in a haughty pose, suggests another common device: shooting the subject from below to create an artificial sense of stature. A FIG. 72 sharp close-up of Castro suggests introspection; another depiction, showing him with his lips parted, about to speak, and his shirt open at the neck, reads as rebellious but human. These paintings, FIG. 71 appearing more like studies than finished works, offer a glimpse of something that political portraits usually strive to conceal: the rituals of posing and presentation. The subjects depicted are not just politicians, but powerful world leaders who, with the aide of their handlers, have learned to play the game well. A glance, a look, a gesture (combined with just the right sound bite or turn-of-phrase) can become a significant vehicle of manipulation and persuasion in a world where the public and the personal, the political and the psychological merge

[3] Michael Newman, "Interview with Leon Golub," in *Leon Golub: Mercenaries and Interrogations*, exh. cat. (London: Institute of Contemporary Art, 1982), p. 5.

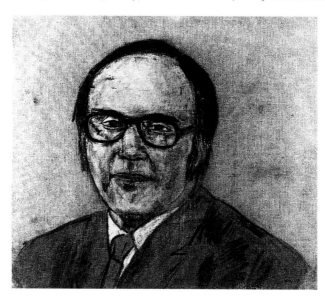

into a powerful continuum of meaning. And when these strategies fail—a problem exemplified by Golub's portraits of Nelson Rockefeller—the results, of course, can spell political danger.

The point of Golub's images is that to one extent or another the staged portrait almost automatically reduces the face to a kind of essentialist moment that can either work to a politician's advantage or disadvantage; individual features, expressions, even skin color and texture coalesce into a generalized signification of personality, sensibility, or identity. This process of essentialization, of course, merely extends the general tendency of photography to kill any sense of animation: "What do I do when I pose for a photograph," writes the critic Craig Owens. "I freeze—hence, the masklike, often deathly expression of so many photographic portraits....I freeze, as if anticipating the still I am about to come; mimicking its opacity, its still-ness; inscribing across the surface of the body, photography's 'mortification' of the flesh."[4] Photography's little murder (one that the politician often conspires to work against), is naturally not without ideological significance, for its "mortified" flesh is invariably reanimated by meanings that only the photograph can bracket and isolate. Who determines this meaning is always to a certain extent ambiguous. On one level, the wishes of the subject may be irrelevant, since most mass-media images, like Golub's portraits, reverse the traditional art historical dynamic of ownership and patronage; the subject now has little or no economic control over the manner of representation. Yet, by recirculating images intended mostly for public consumption, Golub also reappropriates the very rhetorical and stylistic means by which political figures construct themselves for public consumption.[5]

As such, the artist captures the way the human face is transformed by the media *and* the

[4] Craig Owens, "Posing," in *Difference: On Representation and Sexuality*," exh. cat. (New York: The New Museum of Contemporary Art, 1984), p. 12.
[5] Of course, we all are involved in mechanisms of self-construction and self-production. Indeed, a number of intellectuals and activists have argued that it is through such performative acts—through the garments and cosmetics we wear, the expressions that register on our faces, the gestures we make—that we may disrupt the stereotypes that define and ultimately imprison us. See, for example, Judith Butler, "Imitation and Gender Insubordination," in Diana Fuss, ed., *Inside/Out: Lesbian Theories, Gay Theories* (New York and London: Routledge, 1991), pp. 15-29.

75. GEORGE LUKS PORTRAIT OF SECRETARY FRANKLIN LANE 1919

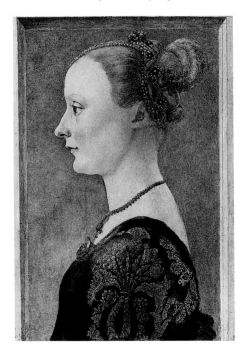

subject, revealing the extent to which affect and expression are neutralized, poses are conventionalized, and character and personality are telegraphed. "For all their 'objectivity,'" Golub has said, "these portraits are 'skins' with no bones or muscle underneath, perhaps like the rubber masks one can buy in Times Square."[6] Golub has compared this effect to the way one glances in a mirror in search of just the right surface expression—a metaphor that underscores the media's power to reduce the face to a commodifiable two-dimensional cipher.[7] "In the mirror, your external appearance, your face, already has the status of an object," writes cultural critic Judith Williamson on the pervasive conceit of the mirror-reflected face in advertising, "so it can easily become an object

that is the property of the manufacturers—but one held up as purchasable. Thus our faces already having been removed from us (you cannot *see* your own face) by the mirror, can be taken over completely, as the only time your face *ever* appears to us completely is at a distance, as an *image*."[8]

While Golub's portraits recreate the visual sensibility of television and newspapers, their lush brushwork, skilled draftsmanship, and unprimed surfaces remind us that even in the realm of high art, the portrait transforms the face into an ideologically impacted icon. The formulaic, repetitive compositions of most portrait paintings, photographs, and sculptures tell us that their formal structure is rooted in the need to communicate through easily recognizable devices. "The basic

[6] Newman, "Interview with Leon Golub," p. 5.

[7] For more on this issue, see Thomas McEvilley, "Frontal Attack: The Work of Leon Golub," in *Leon Golub*, exh. cat. (Mälmo: Mälmo Konsthall, 1992), pp. 37-41.

[8] Judith Williamson, *Decoding Advertisements: Ideology and Meaning in Advertising (Ideas in Progress)* (London and Boston: Marion Boyars, 1978), p. 68.

FIG. 76

schema on which the 'markers of individuality' are placed," writes art historian Norman Bryson on the Renaissance profile portrait, "is starkly visible, as a harsh profile which, though enabling the statement of a considerable quantity of information concerning the unique physiognomy of the sitter, nevertheless threatens the structure of presence by allowing the repetitiveness of the formula...to show through."[9] The endless repetition of these formulas—from the clichés of the pose and point-of-view to those of framing (e.g., "full-body" or "three-quarter" view)—further isolate them as cultural conceits. In this way, the portrait's humanistic pretensions, its desire to capture the individual spirit or personality, are always compromised, to some degree, by the need to produce generalized meaning through socially encoded formal devices. It is through these codes of presentation, along with such contextualizing devices as props, ambient settings, titles, captions, and frames, that the portrait can fulfill a set range of ideological purposes, including the ennobling of the sitter, the marking of identity or familial hierarchies, or the signification of power, wealth, greatness, sanctity, love, or evil.

If these codes allow the portrait to possess universal meaning—to create myths of innocence or evil, power or weakness, triumph or tragedy—it is the political portrait that has served as an important coordinate for establishing social and cultural signification. There is a sense that the real itself is always stuck in the approximate, waiting for an act of re-presentation to make it relevant and meaningful. This may well be the point of Golub's extraordinary portraits: cataloging the standard devices of political portraiture, the artist also simultaneously demonstrates how the vicissitudes of form and surface mitigate, and even produce, social meanings. Golub's aesthetic universe, then, is no different from the rest of Western culture—a visual playing field that perpetually compels us to make and remake the faces that tell the world who we are.

[9] Norman Bryson, *Vision and Painting: The Logic of the Gaze* (New Haven and London: Yale University Press, 1983), p. 124.

PORTRAITURE
AND
PERFORMANCE

Max Kozloff

An individual before a portrait camera faces a challenge, minor or momentous, as the circumstances warrant. For in the interval that precedes the photographic exposure, he or she is required to make an impression that is by no means certain, and under conditions that are unstable. Sitters prepare themselves as appropriately for the occasion as they can. For they know that each impression is registered and concluded with each opening of the shutter. The ritual in which they are involved is discontinuous, filled with one or more "takes," from which there is no appeal. In contrast, those who sit for a painter are engaged in a much more open-ended activity, without climaxes. For them, each moment on the portrait dais slides imperceptibly into another. The figure they cut is not recorded by light as it hits film at a particular instant, but is summoned and pictorially created at the behest of a mind.

A portrait painting is the result of a notion of a subject that may or may not be based on close study, coded in expressive marks that are accrued over time. No matter how acute and specific the image, it is built up through subjective memory or conjecture (the subject need not be present), and a modulation of strokes that are synthesized or revised in a cumulative, relatively long-term process. Whatever else it is, however, a portrait *photograph* acts as the product of an interchange between the photographer and the sitter or sitters at a specific moment. The image comes to us as a trace of circumstances which the two parties consciously shaped together at that fugitive instant, and no other. Even the most rigid portrait photograph therefore implies the mutability of the subject's appearance, as well as the immediacy of his or her presence. We deal with the picture as a visual instant extracted from the course of the life lived by the person. While it profits as a mode of physical witness, the photograph is correspondingly less privileged than a painting in its ability to endow the subject with a symbolic guise. Through vagaries of timing or mood, the chances are good that the extract from the sitter's life might prove to be trivial, random, or unrepresentative. To reduce that possibility, portrait photographs are most often accented through a familiar device which we encounter as the subject's *performance*.

The performance is a mode of behavior induced or constructed and staged for the occasion of the portrait. Here I want to consider this active word "performance," as compared with "pose," the term we ordinarily use to describe the bearing of the sitter. One poses *for* x, but one performs *as* y, implicitly for an audience. Both words refer to the same situation of the one depicted, but inflect it differently.

Any question about the role played by portrait subjects must start with their arrangement in pictorial space. Broadly speaking, a pose designates what is configured in a portrait, a self-presentation that may include the subject's display of

77. Peter Hujar Edwin Denby 1975

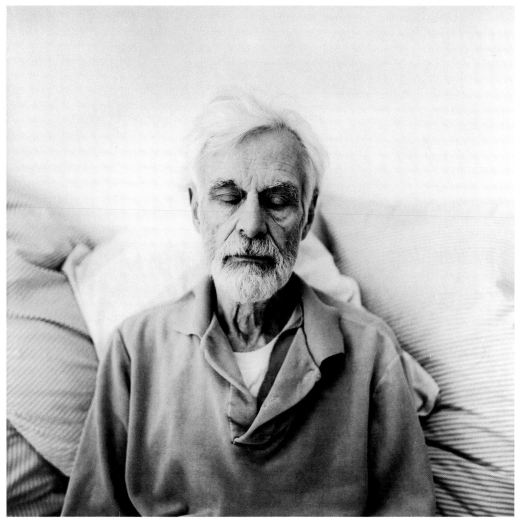

accessories or possessions. It is a temporary state of being, provisionally adjusted and settled. I mean by "pose" the placement of the body independent of any attitude that is struck or of facial affect. The hands may be unfolded, the head turned at a slight downward or left-leaning angle, an arm may be stretched or bent around the back parapet of a chair. Physical comfort, in such cases, could have guided the position of the limbs, affected by a self-consciousness that assumes gestures. Through it all, there must also have run certain negotiations between the sitter and the photographer, pronounced with whatever degree of emphasis the restraints of time, place, etiquette, job, and personal chemistry afforded them in their mutual business.

Most portrait photographs, therefore, are collaborations, the results of short, lost histories of human give-and-take. From the first, the transparence of the photographic means nevertheless left some trace of that history, which may hover in the demeanor of the sitter, or in the very air or light of the picture and the way it is framed. Obviously, too, if we speak of a scene that has been jointly put together by the two parties of the production, we do not talk about them as altogether free agents. Their interests have shaped or even hemmed in each other. A portrait ritual is a power combine, and if brought off on friendly, civil, professional, corporate, or adversarial terms, is apt to reflect something of the psychology of such relations, along a sliding scale of intimacy. Let me show how power is dramatized by a comparison of two *adversarial* portraits, in which the (very simple) pose is under siege.

In search of new—disadvantaged—subjects for his portrait aesthetic, the fashion photographer Richard Avedon traveled during the 1980s in the American West. There, he built up a vast portrait gallery of people who toiled in filthy, low-paying jobs, or were unemployed and meanly used. He does not seem to have had any feeling for these strangers, one way or another. But he saw that repulsive details, enlarged beyond life scale for museum exhibition, make for pictorial excitement. So his portraits of American Westerners are put-downs in effect, though not consciously judgmental. We can see by the pose that his subjects were not yet alerted to the photographer's real indifference. For he approached people on apparently neutral professional terms, even as he worked upon them to achieve his far more self-involved, uncaring, and determined effect of style. Viewed at extremely close range with a big camera, and confronted by a small team, they are defensive or sometimes wary in their self-assertion. They had little or no room to maneuver, and their tentative stance contrasts with Avedon's aggressive approach.

In a more extreme case, the poses, and indeed the very presence, of the unveiled Algerian women photographed by the French soldier Marc FIG. 78 Garanger in 1960 were coerced. He was under orders—and therefore coerced himself—to make identity photos of village women, which he did at a daily clip of two hundred for ten days. Like Avedon's, these pictures are tokens of the contact between an "advanced" society and a dangerous or a vulnerable culture, perceived as alien. In Algeria, Garanger's subjects had to take their place in long lines, monitored by uniformed men with guns. He was, in fact, opposed to the Algerian war, and hoped in vain that these mug shots would reveal his sympathy for its victims. Instead, many of

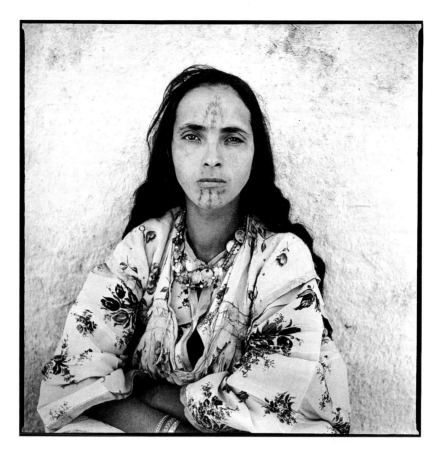

78. MARC GARANGER FEMME ALGERIENNE 1960.
GELATIN SILVER PRINT, 10 X 8. © PHOTOGRAPHIES MARC GARANGER.

them blaze with defiance at the infidel who compelled them to bare their faces, and who therefore violated and dishonored them as Muslim women. Jammed up against a wall, their bodies were not allowed to protest his external control, but Garanger could do nothing with their piercing eyes. Thus the bureaucratic work of the identity portrait is stared down by the rage it inspired in its subjects. Without any artistic intent, his pictures are weighted with a power of real human conflict—a power that art seldom reaches. On this level, the comparison between the Algerian women and the American Westerners is unfair to Avedon.

If the circumstances in these two cases inhibited the arrangements of pose, they were fatal to the development of their subjects' performance. In order to perform, the people in a photograph, before anything else, require a certain degree of psychic comfort. We register portrait performance as confident and relatively at ease with itself. And this is so even when the aim of the performance is to indicate a level of emotional distress. A portrait performance is an attempt to allude, through visual means, to a larger or more complex personal identity than is demanded by institutions. Which is not to deny that it is quite often stereotyped by genre—as, for example, in celebrity portraits (of which more later).

A pose, in contrast, is an element that may contribute to a performance, but is by no means the equivalent of it. In the nineteenth century, or among rural or non-Western cultures today, the stances of people portrayed by the camera conform more to our idea of elemental poses than to performances. The subjects were encased by a social mold or fixed status within a hierarchical scheme. Such class-bound camera sessions served to uphold the dignity of sitters, but deprived them of any repertoire of interactive signals with others. One suffered the portrait ritual, supported by one's aboriginal power, in a form of strenuous display about as much open to speculation and personal disclosure as a statue. Everywhere, in pictures of such type, we sense the absence of conditions relaxed enough, socially, to permit sitters to *seem* to be someone, and not just creatures defined by their place in the communal order.

This constraint was quite early sidestepped by the work of the French portraitist Nadar in the 1850s. In some of his photographs of artists and intellectuals, an implied mobility of body language corresponds to a sense of the personality that is itself fluent, conscious of its own variousness. People start to unbend; blood flows through their bodies. A good many of them are lit up by the very contingency of their occasion. Nadar permitted them to swagger or be moody, even to smoke. No doubt they were special subjects, with a professional interest in projecting their interior states—the expansive life they led in the mind. The entrepreneurial Nadar was sensitive to, and perhaps even encouraged, that interest as a self-invention, favorable to his sitters and himself as new public personas. The liveliest moments in his portrait output are those in which the subjects gaze out at the camera, as if to take Nadar's measure on their own shrewd, reflexive terms. Alphonse Daudet does it with a sad tentativeness; Champfleury (who knew that he was disliked by the photographer), with real skepticism.

FIG. 79

But another, and very different form of portrait performance debuted slightly later in the work of Julia Margaret Cameron. This English gentlewoman portrayed intellectual celebrities of

FIG. 8

79. Nadar (Gaspard Félix Tournachon) Rossini, before May 1856.
Salt print, from wet-collodion glass negative, 9⅛ x 7⁷⁄₁₆ in. The Museum of Modern Art, New York,
Gift of Paul F. Walter. Copy Print © 1995 The Museum of Modern Art, New York.

80. Julia Margaret Cameron Mrs. Duckworth 1867. Albumen-silver print, 13 ¾ x 10 ¾ in.
Collection Paul F. Walter.

her era, or friends and family, as if they were types in venerable dramas, like the Bible, or in poetic allegories, like Tennyson's. Insofar as she assigned roles to her sitters from preexisting texts, Cameron's portrait impulse was illustrational. Far from allowing her subjects to react to her in their joint space, they were cast into their own, apparently self-contained and vaporous world. They were identified by their own names in the titles of the pictures, but they were also considered as stand-ins for fictive characters. Some attempt is even made to substitute for, or play down, the contemporaneity of their dress. Such a literary mode of performance was fairly new in photography, although familiar in genre painting and theater. Cameron is like Nadar in her desire to see "into" characters, and to bring out something of an interior force that animates and kindles their faces. But the illustrational intent in much of her work made for an unacknowledged contest of wills between her and her sitters. A sustained performance of frozen introspection or soulfulness, during lengthy exposures, took its toll on their spirits. It is hard to tell if their memorable intensity comes from empathy with their role or is the result of being harried by the photographer.

From a viewer's vantage, normal portrait performance is seductive and inconclusive. The picture evokes the awareness of human beings as a mix of self-projected and self-contained behavior, in unclear ratios. But that ill-definition is social, if only because it conforms to our own sense of being in the world. People who at one end of behavior are always hyperbolically on stage or, at the other, evidently autistic, are hard to interpret for social purposes, either in pictures or in life. But the thing that makes the portrait special is the working of its artifice, through which the sitters' energy is directed, for appearance's sake, to enact a representation of themselves. *A performance is a form of direction that amplifies and tries to spell out what the pose can only indicate.*

By means of the historical examples I just cited, we also see that performance can take two different lines that are roughly antithetical to each other. For a personality can be *affirmed* by performance, as in Nadar, or *masked and replaced*, as in Cameron. To be sure, the issue in both their performance modes is the apparentness or conviction of the traits that are mimed, in a charade that maybe has its own conventions. Cameron's and Nadar's freshness, their kinetic treatment of the face, is a reflex of the fact that they were making up performance conventions as they went along. That kind of improvisation inevitably begs the question of the "who" they actually portrayed.

What's in a name? What's in a face? The ego steps out of so many modern portrait photographs, contracted by one or another of the age's continually shifting ideas of the individual. In addition to the memorial functions of the photograph, and its work in defining the social status of the sitter, the image is given a further job: as reference to someone's unique identity. By "identity," I don't mean any physical attribute which sets a person apart, and which can be distinguished by traces such as fingerprints or voiceprints. Nor do I allude to the insistence on expressive body fragments, if it eliminates the all-crucial face. Rather, the word "identity" signifies a person's singular character as manifested by external and internal conditioning, intimately fused. People in portraits would be known traditionally enough by their

81. PETER HUJAR PAUL'S LEG 1979

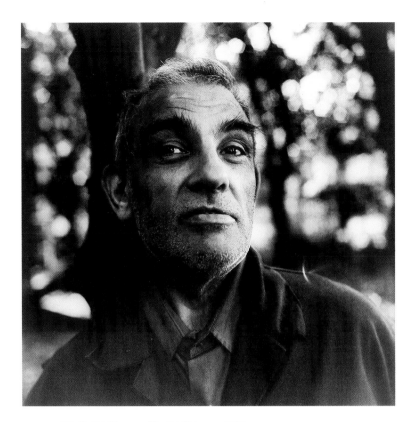

82. Peter Hujar Mental Patient 1981

self-worth, but a modern consciousness establishes self-worth not so much by the things people had in the world as by the unpredictability of their dramatic flair.

For all that the camera is a wonderful instrument to describe the material environment, it's not the best means to penetrate to the invisible psyche. Portraiture is really a difficult art which pursues an elusive aim with limited equipment. To redress such odds, there arose the notion that we are all of us players of roles that have personal content, may be freely chosen, and could be pictured. This is not an idea about sincerity, but utility. It assumes a self-interested relationship between human will and its myriad social enactments, each one of the latter a trace of the former. Such a laissez-faire view of personality has been contested, perhaps even superseded, in the media that had been originally spawned by the capitalist economics of liberalism. If we think of portraiture, an anti-liberal impulse shows up particularly in the celebrity photograph, where the performance of a role *dominates* all other concerns.

A star is a professionally simulated persona, enveloped in an aura that has been typed and then commodified. This formula applies not only to American entertainment figures, but to politicians and all others who briefly glow in our public life. A celebrity portrait works as our democratic culture's version of a dynastic portrait. Elevated in the glare of lights, the subject of such an image is not like us. He or she is bathed in charisma and doped with a narcissicism that recalls the distinctions that premodern portraiture constructed on the basis of class. Above all, no one can determine the distance the featured personality has traveled from the soul that existed before glamour or

renown intervened. And any private subjectivity of the creatures in such portraiture is a hostage of their fame. It makes no difference whether they are treated as silver screen icons by George Hurrell or as grimacing, hokey hotheads by Annie Liebowitz: they're equally indecipherable as persons. How mistaken we would be to expect a revelation of identity from a genre that announces itself as illustrational and propagandistic.

That postmodern culture has created a race of de-individuated people is an academic cliché of our day. Taking its cue from phenomena such as advertisements or celebrity portraits as well as art, the argument runs roughly as follows: instead of being able to choose, we are programmed to play social roles. Power descends from remote corporate and media agencies to mold opinion and conduct on all levels. Forget that we ever thought ourselves responsible for our deeds, guided by freely determined moral values interacting with community mores. (In her early work, Cindy Sherman, a lineal descendant of Julia Margaret Cameron, forges counterfeit identities for her own person in an illustrational context so extreme that we can no longer imagine it to be self-portrayal.) Postmodernist theory has been heavily involved in questions of personal inauthenticity, the artifice of bad faith, and the substitution of performance for an increasingly questionable spontaneity. Some time ago, the theory got to the point of insisting that there is no such thing as an integral or unique human self. The media were supposed to have dissociated us from anything like that.

But this critique of performance is strangely not psychological enough to apply to the vast areas of human behavior outside or even sometimes deeply touched by the media. Instead of a

deceptive attempt to symbolize some personal truth, social performance is more commonly understood as an improvised means to negotiate and perhaps to defend ourselves in scenes where we may have some latitude but no recognized edge of power. Any notion of *portrait* performance most likely has to take into account just such normal human feelings, spurred by random contact, and remembered or guessed at from our own experience. Portraits which assumed otherwise could only be thought of as naive con games.

I spoke before of the projective, and now I should emphasize the defensive aspects of performance. Sitters for portraits are given an intermission in which to compose themselves out of both these reserves in their social being. They are no doubt pressured at the moment by the other agent, the one whose business it is to look. But at the same time such a regard records them in a lasting imprint, which they know may well endure beyond their own lives and speak to posterity. Given that knowledge, it's up to the sitter to choose whatever guise seems effective, according to the light of the moment.

With this thought in mind, how illuminating to compare two images in which the "con game" of performance is superimposed upon nothing less than the death scene of the sitter. Hannah Wilke presented herself during the last wretched hospital days of her life, dying of cancer, in front of her own camera, and Candy Darling orchestrated himself in mortal extreme to be photographed by Peter Hujar. These portrait subjects had utterly opposed ideas of self-disclosure. They were powerless to halt their condition, but they could dramatize their reaction to it. If they assumed that future viewers couldn't refrain from

ATE 83

ATE 84

looking upon their performance, with whatever combination of fascination, grief, and uneasiness, they were right.

In her self-portraits, Wilke, a conceptual and installation artist, familiarizes us with the pain she suffers through the disfigurements—the sinister bloating and swelling—of her body. Not only by means of pitiless color detail and clinical lighting, but by the enormous scale of her self-portraits, she stresses her traumatic condition. The effect is something like that aimed at by Richard Avedon, except that it is relatively styleless, exhibitionistic of subject, and for real.

Hannah Wilke wins the power trade-off in this portrait series, obviously because she called the shots and also, all the more remarkably, in view of her subject, the loss of her life. Just the same, the real concern of this work, as well as of Hujar's single image of Candy, is the theme of feminine beauty. Everyone's death is a maiden voyage, a first experience which is also one's last. But beauty is a perennial dream that rises up in the consciousness, is swept away and could come again. It may also be a physical state, as it had once been Hannah Wilke's. Never "correct" when she flaunted her allure in previous works, she showed its corruption in these final images, which she collectively titled *Intra-Venus*. Other portrait campaigns that treat mortally sick people come to mind—those, for example, by Nicholas Nixon or Eugene Richards. But this one is unique because it is comparative. There are moments when Wilke has no energy to pose, let alone perform; in others, she dresses as a Madonna mourning at the cross, or piteously covers her lower face, a shaven-headed inmate of Auschwitz. This woman wanted us to remember the way she was, how she imagined herself, even,

83. Hannah Wilke July 26, 1992/Feb. 19, 1992 #4 from Intra-Venus 1991–93

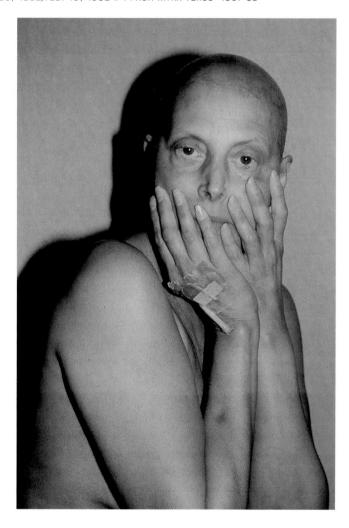

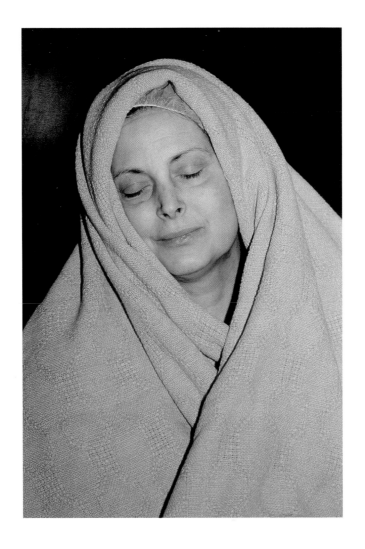

as a star—although now the sense of it echoes only faintly in her unsparing treatment of the way she is. The comparison shows itself particularly in the loss of hair, which changes the whole configuration of the face and is here a fatal sign.

In contrast, Candy Darling lounges seductively on his hospital bed, sealed off by his double impersonation as a woman and as a healthy person, in a fixed moment of eternal remembrance. This "come-on" is also a lying-in-state, betokened by the flowers, particularly the black sprig of rose on the white bed linen. All is performance, but of a type that lets—or rather makes—you see that it enacted for the sake of the performer far more than

it seeks to convince a viewer. The generosity of Hujar's photograph extends itself to that level of being. We are free to deconstruct the sitter's performance, but are perhaps stayed by the thought that the "seeming" becomes him. He, as well as Wilke, are centered by the very unlikeliness of their charades. And then a memory might take over: of those stricken people who put on an act in order to reduce our fear, and in a less effective way to deny their own.

Out of tact and fellow feeling, finally, we respect such impostures, for they are pertinent to the lives of these sad actors, and those who witness them.

Michele Wallace

*In the images of style we see a world where the mar-
ketplace becomes its own, closely watched, opposition.
That world is utopian: cost is no object; work holds no
restrictions; desire has no conscience; each moment is
self-governed.*

—STUART EWEN, All Consuming Images[1]

*There is real power in remaining unmarked; and there
are serious limitations to visual representation as a po-
litical goal.* —PEGGY PHELAN,

Unmarked: The Politics of Performance[2]

Let's face it. Advertising is usually a shady
enterprise. Although I don't personally
believe that evil is irreversibly written on its soul,
for the most part it tends to operate like a passive-
aggressive friend who is actually your worst enemy,
the one who likes to bring you to your knees in pain
but always with a smile.

Various kinds of unsavory manipulation
are part and parcel of advertising's bag of tricks. In
particular, among those print ads aimed at con-
sumers of women's clothing, which take up more
pages than anything else in most women's maga-
zines, the repertoire is usually confined to two pos-
sible mind-sets.[3] These are: the "don't you wish
you were rich" ads for expensive clothing; and the
"don't you wish you were young and beautiful"
ads for downmarket clothes.

Because of my longstanding fascination
with women's magazines, and my insistence on

speaking about it publicly in the past five years or
so, I have become well aware that many people, es-
pecially most feminists and / or black intellectuals,
think that the solution to the advertising problem is
simply to get rid of it. But this is no longer a viable
solution, if indeed it ever was. The main reason is
that no contemporary industry has its finger more
on the pulse of the multinational postcapitalist
computerized Zeitgeist of the twentieth century
than advertising. As technological advances in
computers, communications, film, video, CDs and
CD-ROMs come zooming down the pike, the ad
agencies are always the first to swoop them up in
their chilly embrace.

But the truth is that, despite the mendacity
of almost all the information advertising provides,
it nevertheless continues to define us. What wor-
ries me more, however, is advertising's moral
depravity. So much so that everybody hates adver-
tising except the people who depend upon it to
make a living. If advertising were more subtle and
ethically rigorous, it would be much more persua-
sive and interesting. We have seen this in the enun-
ciative power of many public service messages for
charities and philanthropic endeavors of one kind
or another. The most moving recent use of adver-
tising strategies has developed around the AIDS
crisis.

But for anybody who cruises magazines as
habitually as I, the advertisements which seem able
to employ this kind of power stick out like a sore

[1] Stuart Ewen, *All Consuming Images: The Politics of Style in Contemporary Culture* (New York: Basic Books, 1988), p. 108.

[2] Peggy Phelan, *Unmarked: The Politics of Performance* (New York: Routledge, 1993), p. 6.

[3] A few years ago, in the inaugural issue of the new *Ms.* magazine, Gloria Steinem wrote an article explaining why *Ms.* would no longer include
any advertising. In the process, she recounted a fascinating history of the problems *Ms.* had had in coping with advertisers and, thus, the subtle
ways in which they can impact on editorial decisions, particularly and especially in women's magazines. No other kind of magazine is so influ-
enced by its advertisers. Personally, I believe it is because women will put up with it.

thumb. The self-congratulatory multiculturalism of the Benetton ads has been attracting a lot of attention for a long time but they never quite cut the mustard for me, although I was glad to see so many models of color getting work. But their voyeurism and fetishism, what Peggy Phelan calls the "the colonialist/imperialist appetite for possession,"[4] became much too transparent. Black or brown skin photographs so beautifully that when advertisers finally use black images, it is difficult to resist sensationalizing or fetishizing the color and texture.

Moreover, as Phelan explains, visibility can be a trap:

As critical theories of cultural reproduction become increasingly dedicated to a consideration of the "material conditions" that influence, if not completely determine, social, racial, sexual, and psychic identities, questions about the immaterial construction of identities—those processes of belief which summon memory, sight, and love—fade from the eye/I.[5]

[4] Phelan, *Unmarked*, p. 6.
[5] Ibid., p. 5.

The clothing companies which have shown the most freedom in deviating from the manipulative norm are those that have a product which is reasonably priced and nearly essential. The series of Gap ads that use old photos of various ultra-hip celebrities, many of whom are dead, provide the exemplary instance.

The Gap has been chief among recent business success stories in apparel sales. As its name signals, it found a veritable gap in the marketplace for selling the kind of clothing that everybody wants to wear most of the time—durable, comfortable, informal, rugged, virtually timeless classics such as khakis, sweats, jeans, T-shirts, flannels, and so forth—at reasonable prices in an endless chain of conveniently located stores. No razzmadazzle, no bullshit, no smoke and mirrors. Just product with very little malarkey or mark-up. Granted (as my husband the bargain shopper reminds me), you can find cheaper versions of everything at the Gap somewhere else if you have several hours to kill, but you can't beat the Gap for the utter absence of tedious frustration surrounding the act of the purchase. So, on general principles, I have always thought well of the Gap.

But when I started to notice this series of ads in the spring of 1994, it immediately got my attention. So far as I could tell, the ads appeared only in *The New Yorker* and *The New York Times Magazine*. They were all exactly alike in this respect: each was a black-and-white photographic portrait of a cultural icon in a revisionist canon of American modernism, a modernism which included generous numbers of artists who were black, Asian, female and/or queer, as well as artists who weren't necessarily high cultural but whose achievements in popular culture we now recognize as having been of the highest quality.

These ads, in which each of these icons—male or female—was wearing khakis, never even appeared in any of the women's magazines. Moreover, virtually none of the subjects could have been actually wearing Gap khakis since all the photographs, except perhaps the one of Allen Ginsberg, were taken before the company's existence. The product—to the extent that there was a "product"—was clearly being marketed as evocative, historically remote and unseen rather than immediate, material, and substantial.

I haven't yet figured out whether I find black-and-white photos emotionally resonant because most of my old family photos are in black-and-white, or because there is something intrinsically evocative about black-and-white photos. Whichever the case, these pictures, leaked slowly (so slowly that you could have easily missed them), one at a time and a week at a time, of Miles Davis, Sarah Vaughan, George Balanchine, Marlene FIG. 86 Dietrich, Sal Mineo, Montgomery Clift, Truman Capote, Leonard Bernstein (the dead ones), as well as Gordon Parks, Isamu Noguchi, Paul Bowles, Bobby Short, Frank Sinatra (in their FIG. 85 youth) caused a lump to rise in my throat and a dampness to appear in the corner of my eyes.

And the fact that the campaign lingered on throughout the summer but faded in the autumn (along with everything else sweet) as the more frenzied campaigns aimed at the back-to-school/Thanksgiving and Christmas crowd gobbled up all the attention, only made them that much more miraculous. They never felt big, or splashy, or common. Moreover, they seemed to advertise, finally, something people of my generation and cultural education already had—Davis', Vaughan's

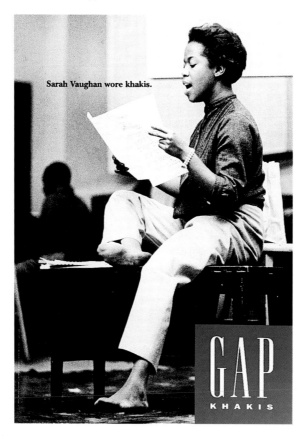

Sarah Vaughan wore khakis.

GAP
KHAKIS

and Bernstein's music, Parks' photographs and films, Capote's and Ginsberg's writing, etc.

Each one featured the following messages: in the right-hand lower corner, there was a box marked "Gap Khakis" and somewhere near the head of the subject, were the words "Montgomery Clift [or Sarah Vaughan or Miles Davis] wore khakis." In the various pictures, the artist is clearly wearing a version of khaki pants, rolled up around the ankles in the case of Bowles, Parks, Capote, and Short, paint-spattered in the case of Noguchi,

accessorized with sneakers in Sinatra's case, with pearls in Vaughan's case, with socks and ballet slippers in the picture of Balanchine.

FIG. 87

These ads are sexual in that they feature the bodies as well as the faces of these celebrated individuals. In order to see the pants they are wearing, we must see the entire body. The emphasis is, in fact, on the body, or on how these special people inhabit their bodies. These pictures are perhaps not the most distinguished on photographic terms; but in terms of the aesthetics of the body, they are

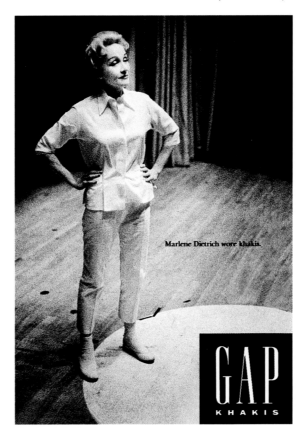

Marlene Dietrich wore khakis.

GAP
KHAKIS

beautiful and fascinating indeed in a society and a context in which visibly represented bodies are only supposed to be young, perfect, and thin. An exuberant Capote leaping through the air in perhaps the most famous of these photos is emblematic of their energy.

Montgomery Clift is shown standing on a ladder in a kind of twisted three-quarter profile, dipping a paintbrush in a can of paint with his right hand, his sleeves rolled up as if he were about to get to work. And yet we know that Clift (who appears to be in his mid-twenties) was not a house painter at this stage of his life but a very famous and talented movie actor. Moreover, most of the wall looks wallpapered and there is dark wood trim along the ceiling. There is no tape and no drop-cloth; no attempt has been made to cover the areas that could easily be splattered by paint. As a result, I surmised that this picture must have been a production still of some sort taken during rehearsal. Clift is not looking at the camera and his left hand is in his hair, which I was able to determine mostly

by the shadow the hand made on the wall behind, a sign that he is standing in an intense and artificial light, perhaps movie lights.

Clift is maddeningly handsome, his face sensitive and poetic, his physique trim and just short of bony. His image recalls to me all the roles he has played that I've enjoyed: the unfaithful suitor who is ultimately rejected by the older and wiser Olivia de Haviland in *The Heiress*, the psychiatrist who must decide whether to lobotomize the beautiful Elizabeth Taylor in *Suddenly Last Summer*, the young man in *A Place in the Sun* who kills a chubby (although magnificent) and supposedly pregnant Shelley Winters in the middle of a lake in a rowboat.

Although these films, and so many others of that period, featured exclusively white casts, the resonant, evocative play of light and dark in black-and-white film may have facilitated our imagining otherwise. As we watched these films on TV as children, they taught us the essentials of human character and conventional melodrama, crucial information for understanding the inner dynamics of American popular culture and modernity; lessons I will never forget and of which I enjoy being reminded.

FIG. 86

The Vaughan portrait, dated 1950, is definitely an impromptu shot. Vaughan is sitting with her shoes off, one of her feet up on a piano stool, the other swinging slightly above the floor, intently focused on a piece of sheet music. Her mouth is open as if she were singing. The rest of the scene is in fuzzy focus, but it appears to be a music studio situation. There are pearls around Vaughan's wrist. She is young, which tells me this picture was taken when her voice was unbelievably clear as a bell, and I am reminded of the times I saw her sing and what an incredible musician she was, one of the greatest jazz singers who ever lived.

One thing I loved about Vaughan on stage was the way she inhabited her body. Although not a classic beauty, nevertheless she always seemed so strong and attractive, so comfortably situated in her body as the sweat poured down her brow and as she wiped it gingerly from around the wisps of hair that framed her face.

Although the Bernstein photo is credited with the words "Mary Engel, estate of Ruth Orkin," the copyright line also says that "Leonard Bernstein is a registered trademark of the Amberson Group, Inc. courtesy of the Beta Fund," whatever this means. The picture shows a youngish Bernstein conducting, obviously in rehearsal, his shirt open at the collar and wrinkled, his feet shod in penny loafers. Several of the cellists in front of him are wearing sunglasses. Perhaps this means they were outside.

The picture was apparently taken around the time Bernstein did the children's concerts on public television. As a child, I watched them all. Several years later, he wrote *West Side Story*, which emerged just in time to accompany me into adolescence. Even though I was still a child, I was extremely aware of the discussions in the black community, in which it was suggested that Bernstein, or more probably the movie studio, had chosen to portray whitened Puerto Rican teenagers instead of gang-banging blacks in order to soften the multicultural blow. Nevertheless, my sister and I practically wore the album out and I still know all the songs by heart. I will always love Bernstein for his music, his politics, and his joie de vivre.

In fact, I just love all these pictures. I can't help myself. And I think it was a marvelous idea on

the Gap's part to revive these vintage photos for the sake of middle-aged people like myself who remember these artists in their prime, or perhaps even for the young people who have grown fond of Tony Bennett and other relics of a bygone age, in the name of a product we have apparently never been without all along.

As for my favorite, I can't say whether it is the one of Dietrich, who has become a personal hero of mine (her daughter makes her sound so fascinating), or Miles Davis, who was so gorgeous in his youth and whose autobiography is still so riveting.

In the one of Dietrich, she is standing on a stage with her hands on her tiny hips, looking fifty-ish but infinitely glamorous still. Her khakis are sleek, very elegant, and cut off above the ankles. Around her tiny feet are the bits of tape that mark where the actors should stand and move when they deliver their lines. She seems resolute and, for some reason, she reminds me of my grandmother, who was also a very elegant person, a fashion designer who modeled herself after Coco Chanel. By contrast, the portrait of Davis is casual. It shows him with the magnificent Miles forehead cupped in his right hand, his left leg thrown over the back of a folding chair, a scarf tied, devil-may-care, around his neck.

These lovely silky old photos, revived and reanimated gingerly and with taste, represent the increasing democratization of the portrait. As such, they exemplify a gradual cultural change: on the one hand, we are growing more and more deeply invested in the superficialities of the image; on the other, through the facility of new technologies, most of us stand to experience a much larger expressive tradition of images than would otherwise have been possible. For the Gap's contribution to all this, I say thanks. Thanks for the memories.

FIG. 87

SELECTED BIBLIOGRAPHY

PORTRAITURE

Brilliant, Richard. *Portraiture*. London: Reaction Books, 1991.

Brilliant, Richard, ed. "Portraits: The Limitations of Likeness," *Art Journal*, 46 (Fall 1987), pp. 171-225.

Collins, Douglas. *Photographed by Bachrach: 125 Years of American Portraiture*. New York: Rizzoli International Publications, 1992.

Feldman, Melissa. *Face Off: The Portrait in Recent Art* (exhibition catalogue). With an essay by Benjamin H.D. Buchloh. Philadelphia: Institute of Contemporary Art, University of Pennsylvania, 1994.

Friedlander, M.J. *Landscape, Portrait, Still-Life: Their Origin and Development*. New York: Schocken Books, 1965.

Gibson, Robin. *The Portrait Now* (exhibition catalogue). London: National Portrait Gallery, 1993.

Goldin, Amy. "The Post Perceptual Portrait," *Art in America*, 63 (January–February 1975), pp. 79-82.

Gottlieb, Carla. *Self-Portraiture in Post Modern Art*. Cologne: Dumont, 1981.

Hepper, Irene. *Bibliography on Portraiture: Selected Writings on Portraiture as an Art Form and as Documentation*. Boston: G.K. Hall, 1990.

Honour, Hugh. *The Image of the Black in Western Art*. Vol. IV, parts 1 and 2. Houston: The Menil Foundation, 1989.

Johnson, Brooks. *The Portrait in America* (exhibition catalogue). Norfolk, Virginia: The Chrysler Museum, 1990.

Koerner, Joseph. *The Moment of Self-Portraiture in German Renaissance Art*. Chicago: University of Chicago Press, 1993.

Kozloff, Max. "Opaque Disclosures (An Examination of the Formal and Informal Modes of Portrait Photography)," *Art in America*, 75 (October 1987), pp. 144-53.

_____. *Real Faces* (exhibition catalogue). New York: Whitney Museum of American Art at Phillip Morris, 1988.

_____. "Variations on a Theme of Portraiture," *Aperture*, 114 (Spring 1989), pp. 6-15.

Pope-Hennessy, John. *The Portrait in the Renaissance*. New York: Bollingen Foundation, 1966.

Porter, Fairfield. "Speaking Likeness," *Art News Annual*, 36 (1970), pp. 39-51

Quick, Michael. *American Portraiture in the Grand Manner, 1720–1920* (exhibition catalogue). Los Angeles: Los Angeles County Museum of Art, 1981.

Stein, Gertrude. "Portraits and Repetition." In *Lectures in America*. New York, 1935.

Steiner, Wendy. *Exact Resemblance to Exact Resemblance: The Literary Portraiture of Gertrude Stein*. New Haven: Yale University Press, 1978.

_____. "Postmodern Portraits," *Art Journal*, 46 (Fall 1987), pp. 173-77.

Varnadoe, Kirk. *Modern Portraits: The Self and Others* (exhibition catalogue). New York: Columbia University Art and Archaelogy Department, 1976.

Willis, Deborah. *Black Photographers Bear Witness: 100 Years of Social Protest* (exhibition catalogue). Williamstown, Massachusetts: Williams College Museum of Art, 1989.

Yau, John. "The Phoenix of the Self," *Artforum*, 27 (April 1989), pp. 145-51.

CULTURAL STUDIES

Aronowitz, Stanley. *The Politics of Identity*. New York and London: Routledge, 1992.

Barthes, Roland. *Mythologies*. New York: Hill and Wang, 1972.

Berger, Maurice. *Ciphers of Identity* (exhibition catalogue). Catonsville, Maryland: Fine Arts Gallery, University of Maryland, Baltimore County, 1993.

Berger, Maurice, and Johnnetta Cole. *Race and Representation: Art/Film/Video* (exhibition catalogue). New York: Hunter College Art Gallery, 1987.

Bhabha, Homi. "Remembering Fanon: Self, Psyche, and the Colonial Condition." In Barbara Kruger and Phil Mariani, eds., *Remaking History*. Seattle: Bay Press, 1989, pp. 131-50.

Boorstin, Daniel J. *The Image: A Guide to Pseudo-Events in America*. New York: Atheneum, 1961.

Broude, Norma and Mary D. Garrard, eds. *The Power of Feminist Art: The American Movement of the 1970s, History and Impact*. New York: Harry N. Abrams, 1994.

Butler, Judith. *Gender Trouble: Feminism and the Subversion of Identity*. New York and London: Routledge, 1990.

Ewen, Stuart. *All Consuming Images: The Politics of Style in Contemporary Culture*. New York: Basic Books, 1988.

Ewen, Stuart, and Elizabeth Ewen. *Channels of Desire: Mass Images and the Shaping of American Consciousness*. 2nd ed. Minneapolis: University of Minnesota Press, 1992.

Fanon, Frantz. *Black Skin, White Masks*. New York: Grove Press, 1967.

Gilman, Sander. "Black Bodies, White Bodies: Toward an Iconography of Female Sexuality in Art, Medicine and Literature." In Henry Louis Gates, Jr., ed. *Race, Writing, and Difference*. Chicago: University of Chicago Press, 1989, pp.223-61.

Halle, David. "Portraits and Family Photographs: From the Promotion to the Submersion of Self." In Halle, *Inside Culture: Art and Class in the American Home*. Chicago: University of Chicago Press, 1993, pp. 87-117.

Hirsch, Julia. *Family Photographs*. New York: Oxford University Press, 1981.

Kuhn, Annette. *The Power of the Image: Essays in Representation and Sexuality*. London: Routledge and Kegan Paul, 1985.

Sekula, Allan. "The Body and the Archive," *October*, no. 39 (Winter 1986), pp. 3-64.

Snowden, Lynn. "American Express: Do you know me? Because You Should Know Me." *Graphis*, 44, (March–April 1988), pp. 32-49.

Wallis, Brian, ed. *Art After Modernism: Rethinking Representation*. New York and Boston: The New Museum of Contemporary Art in association with David R. Godine, Publishers, 1984.

Williamson, Judith. *Decoding Advertisements: Ideology and Meaning in Advertising (Ideas in Progress)*. London and Boston: Marion Boyars, 1978.

Willis, Deborah. *Picturing Us: African American Identity in Photography*. New York: The New Press, 1994.

WORKS IN THE EXHIBITION

Dimensions are in inches; height precedes width precedes depth.

ELEANOR ANTIN (B. 1935)

PORTRAIT OF LYNNE TRAIGER, 1971
(RECONSTRUCTED 1995)
Mixed media, dimensions variable
Ronald Feldman Fine Arts, New York

PEGGY BACON (1895–1987)

PORTRAIT OF ALFRED STIEGLITZ, 1925
Graphite on paper, 5 x 3⁹⁄₁₆
The Parrish Art Museum, Gift of Ronald G. Pisano,
Baker/Pisano Collection

PETER CAMPUS (B. 1937)

THREE TRANSITIONS, 1973
Videotape, 20 minutes
Distributed by Electronic Arts Intermix

WILLIAM MERRITT CHASE (1849–1916)

PORTRAIT OF HARRIET HUBBARD AYER, 1879
Oil on canvas, 48⅛ x 32¼
The Parrish Art Museum, Museum Purchase

TWILIGHT PORTRAIT OF THE ARTIST, 1887
Oil on canvas, 36⅛ x 29⁹⁄₁₆
The Parrish Art Museum, Gift of Ira Spanierman

THE GOLDEN LADY, 1896
Oil on canvas, 40⅝ x 32¾
The Parrish Art Museum, Littlejohn Collection

PORTRAIT OF CADWALLADER WASHBURN,
C. 1906
Oil on canvas, 35½ x 28½
The Parrish Art Museum, Littlejohn Collection

ALICE IN THE MIRROR, C. 1897
Oil on canvas, 35¼ x 32
The Parrish Art Museum, Littlejohn Collection

HOWARD CHANDLER CHRISTY (1873–1952)

PORTRAIT OF SAMUEL LONGSTRETH
PARRISH, 1924
Oil on canvas, 60⅛ x 40⅛
The Parrish Art Museum, Village Collection

CHUCK CLOSE (B. 1940)

FANNY, 1984
Ink on silk paper, 19⅛ x 15⅝
The Parrish Art Museum,
Gift of Friends of the Collection

BILL, 1990
Oil on canvas, 72 x 62
Private collection, New York

ELAINE DE KOONING (1918–1989)

LEO CASTELLI, 1954
Oil on canvas, 54 x 30¼
Collection of Leo Castelli

LYDIA FIELD EMMET (1866–1952)

PORTRAIT OF CYNTHIA PRATT, C. 1919
Oil on canvas, 68 x 44⅛
The Parrish Art Museum,
Gift of Mrs. William K. Laughlin

LEON GOLUB (B. 1922)

PORTRAIT OF NELSON ROCKEFELLER (1941),
1976
Acrylic on unprimed linen, 23 x 18
The Eli Broad Family Foundation, Santa Monica

PORTRAIT OF NELSON ROCKEFELLER (1960),
1976
Acrylic on unprimed linen, 14 x 14
The Eli Broad Family Foundation, Santa Monica

PORTRAIT OF NELSON ROCKEFELLER (1969),
1976
Acrylic on unprimed linen, 30 x 24
The Eli Broad Family Foundation, Santa Monica

PORTRAIT OF NELSON ROCKEFELLER (1970),
1976
Acrylic on unprimed linen, 22 x 18
The Eli Broad Family Foundation, Santa Monica

PORTRAIT OF NELSON ROCKEFELLER (1971),
1976
Acrylic on unprimed linen, 17 x 17
The Eli Broad Family Foundation, Santa Monica

PORTRAIT OF NELSON ROCKEFELLER (1976),
1976
Acrylic on unprimed linen, 18 x 17
The Eli Broad Family Foundation, Santa Monica

PORTRAIT OF NELSON ROCKEFELLER (1976),
1976
Acrylic on unprimed linen, 22 x 19
The Eli Broad Family Foundation, Santa Monica

FELIX GONZALEZ-TORRES (B. 1957)
PORTRAIT OF ELAINE DANNHEISSER, 1992
Painted wall, dimensions variable, to be executed
on site
Collection of Mrs. Werner Dannheisser

LYLE ASHTON HARRIS (B. 1965)
QUEEN, ALIAS AND ID: FOR CLEOPATRA,
1994
Unique Polaroid, 20 x 24
Collection of the artist; courtesy Jack Tilton
Gallery, New York

QUEEN, ALIAS AND ID: MADONNA AND
CHILD, 1994
Unique Polaroid, 20 x 24
Collection of Rudean Leinaeng

QUEEN, ALIAS AND ID: SISTERHOOD, 1994
Unique Polaroid, 20 x 24
Collection of the artist; courtesy Jack Tilton
Gallery, New York

ROBERT HENRI (1865–1929)
LADY IN BLACK, 1904
Oil on canvas, 78 ¾ x 38 ½
The Parrish Art Museum,
Gift of Paul Peralta-Ramos

PETER HUJAR (1934–1987)
CANDY DARLING ON HER DEATH BED, 1974
Black-and-white photograph, 20 x 26
James Danziger Gallery, New York

EDWIN DENBY, 1975
Black-and-white photograph, 20 x 26
James Danziger Gallery, New York

PAUL'S LEG, 1979
Black-and-white photograph, 20 x 26
James Danziger Gallery, New York

MENTAL PATIENT, 1981
Black-and-white photograph, 20 x 26
James Danziger Gallery, New York

RAY JOHNSON (1927–1995)
JANIS JOPLIN, 1971
Collage, 22 x 16 ½
Collection of Sarah-Ann and Werner H. Kramarsky

DUCHAM, 1977
Collage, 17 x 13½
Collection of Christo and Jeanne-Claude

GREEN, 1989
Collage, 20 x 13
Collection of Toby R. Spiselman

PORTRAIT OF MICHAEL ARLEN, 1980'S
Collage, 15⅞ x 15⅞
Collection of Mr. and Mrs. Michael Arlen

ALEX KATZ (B. 1927)

DAVID & RAINER, 1991
Painted metal, 71½ x 32½ x 11½
Robert Miller Gallery, New York

JUSTEN, 1991
Painted metal, 71⅔ x 20 x ½ x 12
Robert Miller Gallery, New York

BYRON KIM (B. 1961)

EMMET AT TWELVE MONTHS, 1994
Egg tempera on wood panel, twenty-five panels,
each 3 x 2½
Max Protetch Gallery, New York

WILLIAM KING (B. 1925)

SELF, 1981
Crayon, colored pencil, and pencil on paper,
14¹⁵⁄₁₆ x 11
The Parrish Art Museum, Anonymous Gift

GEORGE LUKS (1867–1933)

PORTRAIT OF SECRETARY FRANKLIN LANE,
1919
Oil on canvas, 40³⁄₁₆ x 30
The Parrish Art Museum, Gift of Mrs. Robert G.
Henry and Mrs. Robert M. Littlejohn

ALICE NEEL (1900–1984)

THE FAMILY (JOHN GRUEN, JANE WILSON &
JULIA), 1970
Oil on canvas, 58 x 60
Collection of Hartley and Richard Neel; courtesy
Robert Miller Gallery, New York

THE SOYER BROTHERS, 1973
Oil on canvas, 60 x 46
Whitney Museum of American Art, New York,
Gift of Arthur M. Bullowa, Sydney Duffy, Stewart
R. Mott, Edward Rosenthal and Purchase

TONY OURSLER (B. 1957)

MMPI (I LIKE TO WATCH), 1995
Mixed media and video projection, dimensions
variable, to be executed on site
Metro Pictures, New York

FAIRFIELD PORTER (1907–1975)

ANNE, C. 1939
Oil on canvas, 38¼ x 25⁵⁄₁₆
The Parrish Art Museum, Gift of the Estate of
Fairfield Porter

FRANK O'HARA, 1954
Oil on canvas, 34 x 20⅛
The Parrish Art Museum, Gift of the Estate of
Fairfield Porter

ANNE IN A STRIPED DRESS, 1967
Oil on canvas, 60 x 48
The Parrish Art Museum, Gift of the Estate of
Fairfield Porter

ANNE, 1972
Oil on board, 15 x 11⅞
The Parrish Art Museum, Gift of the Estate of
Fairfield Porter

LARRY RIVERS (B. 1923)
PORTRAIT DRAWING OF ROBERT STONE,
1953
Pencil on paper, 16⅞ x 13⅞
The Parrish Art Museum, Gift of Mrs. Maurice Blin

BOY IN BLUE DENIM, 1955
Oil on canvas, 53¼ x 38
The Parrish Art Museum, Littlejohn Collection

JUDITH JOY ROSS (B. 1946)
UNTITLED, FROM PORTRAITS AT THE VIETNAM
VETERANS MEMORIAL, WASHINGTON, D.C.,
1983-84
Six gelatin silver prints, each 14 x 11
James Danziger Galley, New York

GARY SCHNEIDER (B. 1954)
MIRRIAM, 1993
Toned gelatin silver print, 36 x 29
P.P.O.W., New York

ANYA, 1994
Toned gelatin silver print, 36 x 29
P.P.O.W., New York

PEYTON, 1994
Toned gelatin silver print, 36 x 29
P.P.O.W., New York

CINDY SHERMAN (B. 1954)
UNTITLED FILM STILL, #48, 1979
Gelatin silver print, 8 x 10
Collection of Ellen Kern

UNTITLED #183, 1988
C-print, 42½ x 28½
Metro Pictures, New York

UNTITLED #196, 1989
C-print, 66¹¹⁄₁₆ x 43¹⁵⁄₁₆
Collection of Barbara and Richard S. Lane

AARON SHIKLER (B. 1922)
D. LEVINE ON HIS WAY TO FORT PUTNAM,
1957
Oil on canvas, 10⅛ x 8½
The Parrish Art Museum, Clark Collection

MOSES SOYER (1899-1974)
SELF-PORTRAIT, C. 1960
Pencil on paper, 9⅛ x 7¾
The Parrish Art Museum,
Gift of Jane and David Soyer

WALTER STUEMPFIG (1914-1970)
TONY AS A BULLFIGHTER, C. 1955
Oil on canvas, 20 x 18
The Parrish Art Museum, Clark Collection

BILLY SULLIVAN (B. 1946)
NAOMI, 1992
Ink on paper, 14 x 10
Collection of the artist; courtesy Fischbach Gallery,
New York

LORRAINE AND HERMAN, 1994
Ink on paper, 7⅛ x 10¼
Collection of the artist; courtesy Fischbach Gallery,
New York

MASSIMO ME MARINA & GREECE, 1994
Ink on paper, 7⅛ x 10¼
Collection of the artist; courtesy Fischbach Gallery,
New York

JAMES VANDERZEE (1886–1983)

JEAN-MICHEL BASQUIAT, 1982
Gelatin silver print, 10 x 8
Howard Greenberg Gallery, New York

EUBIE BLAKE, 1981
Gelatin silver print, 10 x 8
Howard Greenberg Gallery, New York

MUHAMMAD ALI, 1981
Gelatin silver print, 10 x 8
Howard Greenberg Gallery, New York

ANDY WARHOL (1928–1987)

UNTITLED (UNIDENTIFIED PORTRAIT),
C. 1983–86
Silkscreen enamel on canvas, 40 x 40
The Andy Warhol Foundation for the Visual Arts,
Inc., New York

UNTITLED (UNIDENTIFIED PORTRAIT),
C. 1983–86
Silkscreen enamel on canvas, 40 x 40
The Andy Warhol Foundation for the Visual Arts,
Inc., New York

UNTITLED (UNIDENTIFIED PORTRAIT),
C. 1983–86
Silkscreen enamel on canvas, 40 x 40
The Andy Warhol Foundation for the Visual Arts,
Inc., New York

UNTITLED (UNIDENTIFIED PORTRAIT),
C. 1983–86
Silkscreen enamel on canvas, 40 x 40
The Andy Warhol Foundation for the Visual Arts,
Inc., New York

CARRIE MAE WEEMS (B. 1953)

FAMILY PICTURES AND STORIES, 1978–84
Forty-nine gelatin silver prints, various sizes,
audiotape
P.P.O.W., New York

HANNAH WILKE (1940–1993)

JULY 26, 1992/FEB. 19, 1992 #4,
FROM INTRA-VENUS, 1991–93
Two panels, chromagenic supergloss prints,
each 71½ x 47½
Estate of Hannah Wilke; courtesy Ronald Feldman
Fine Arts, New York

*The exhibition will also include selected publicity
stills, magazine covers, documentary photographs,
and tear sheets of advertisements.*

photography credits

The majority of the photographs have been provided by the owners or custodians of the works reproduced. The following list applies to those photographs for which a separate credit is due.

Don Allen Studio	fig. 42
Geoffrey Clements	plate 33; fig. 43
Dennis Cowley	fig. 18; plate 83
Michael Danowski	plate 12
D. James Dee	plates 77, 81–82, 84
Brian Forest	fig. 7
Greg Gorman	fig. 8
Peter Moore	plate 14
David Preston	plates 49, 53
David Reynolds	*courtesy Ronald Feldman Fine Arts, New York* figs. 71–73
Noel Rowe	fig. 10; plates 16, 28–30, 32, 34–35, 48, 51–52, 54, 55–57, 58–62, 75
Jim Strong	plate 3
Ellen Page Wilson	fig. 15